The Beginner's Guide to
Chinese Painting

Plum, Orchid, Bamboo and Chrysanthemum

by Mei Ruo

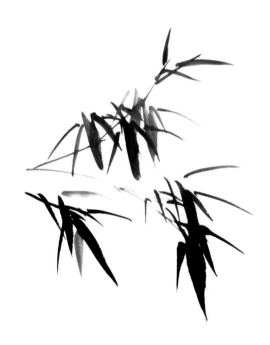

Better Link Press

Copyright © 2008 Shanghai Press and Publishing Development Company

This book is edited and designed by the Editorial Committee of *Cultural China* series

Managing Directors: Wang Youbu, Xu Naiqing

Editorial Director: Wu Ying

Editor (Chinese): Shen Xunli

Editor (English): Zhang Yicong

Editing Assistant: Jiang Junyan, Abigail Hundley

Text by Mei Ruo

Translation by Yawtsong Lee

Interior and Cover Design: Yuan Yinchang, Li Jing, Hu Bin

ISBN: 978-1-60220-109-5

Address any comments about *The Beginner's Guide to Chinese Painting: Plum, Orchid, Bamboo and Chrysanthemum* to:

Better Link Press

99 Park Ave

New York, NY 10016

USA

or

Shanghai Press and Publishing Development Company

F 7 Donghu Road, Shanghai, China (200031)

Email: comments_betterlinkpress@hotmail.com

Printed in China by Shanghai Donnelley Printing Co. Ltd.

3 5 7 9 10 8 6 4 2

Contents

Preface

The distinctive style of traditional Chinese painting and the splendors of its artistic achievement are well known in the world. The literati style of painting has witnessed tremendous growth in China since the Ming and Qing dynasties. Throughout this period many artists have adopted as their subjects what they call "the Four Noble Ones (or Gentlemen)": plum blossom, orchid, bamboo and chrysanthemum, which aptly lend themselves to comparisons to essential human traits.

Plum: Resistance to cold; ability to blossom in harsh winter, frost or snow; symbol of hardy resistance to difficulties and fearlessness when threatened by violence and force.

Orchid: Purity and robustness; delicate fragrance; symbol of incorruptibility.

Bamboo: Because its nodes lend strength even when it is still a lowly subterranean rhizome and it remains "hollow" (symbolizing open-mindness) even when it reaches great heights, it has become a symbol of straightness, loyalty and steadfastness.

Chrysanthemum: It blooms when most other flowers have wilted in autumn. It is compared to a noble-minded person who rises above the baser instincts characterizing society at large.

These subjects have remained popular with Chinese artists to this day.

Plum Blossom

In painting, remember to make full use of all of the five ink shadings: dark, light, dry, wet and charred (burnt). When painting the branch of a plum tree, use light ink for a thick branch and dark ink for a thinner one. In general when the thicker, older branches take up a large space in a painting, rendering them in dark ink would give them too much weight and upset the balance of the pictorial composition.

Brush strokes normally go from left to right and from top to bottom (Figures 1-2). When you get more practiced, you can reverse the directions. After painting the main branch in one stroke, you can touch up with the tip of the brush.

Depth is expressed by the use of different shadings of ink in Chinese painting.

Painting plum branches and boughs in gradated ink tone

1. Branches and boughs should crisscross in the pattern of the Chinese character " 女 " (Fig. 3).

2. Branches in the foreground should be darker and those in the background lighter (Fig. 4).

3. Branches should be painted in curving, rather than ramrod straight, strokes (Figures 5-6).

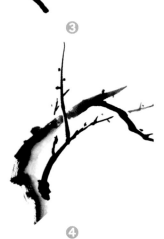

❸

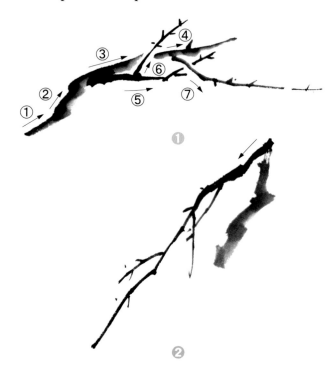

❶

❷

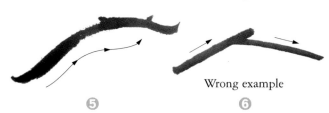

Wrong example

❺

❻

❹

6

4. Note the use of pause-and-twist-back strokes (Fig. 7) to avoid a broken look (Fig. 8).

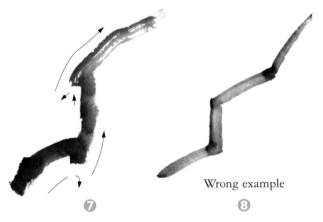

Wrong example

⑦ ⑧

5. Do not connect all the branches and boughs because you need to leave space for the blossoms (Figures 9-10).

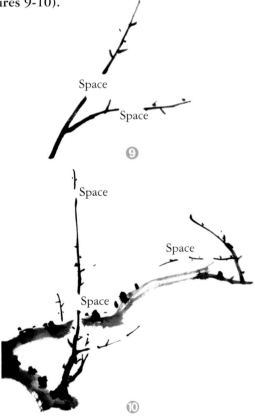

Space

Space

⑨

Space

Space

Space

⑩

6. Pay attention to variations in thickness, length and ink tonality of the branches. If you fail to do a good job in a stroke, you mustn't try to retrace the stroke. You can only try to improve by adding lines around the stroke.

Two ways of painting plum blossoms

Flowers come in all shapes. The plum blossom has five equidistant, equal-sized petals. Depending on the viewing angle, the blossom can be frontal, lateral, upturned, down-turned, upside or underside, in full or half bloom, in bud or wilted. There are accordingly two ways of painting the plum blossoms:

1. Dotting the plum (*mo gu* or boneless style):

The blossom may be front view, side view or back view. In side view, paint three round petals and two oval ones (Fig. 1).

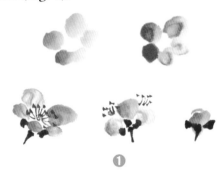

❶

2. Circling the plum (*gu fa* or bone style):

Outline the blossom by drawing curved lines (Fig. 2).

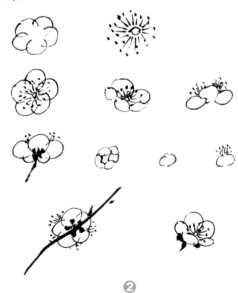

❷

Practice circling before going to dotting, because the former affords an opportunity for a closer scrutiny of the structure of the blossom.

You don't need to put in a large number of plum blossoms in a painting. Chinese culture values understatement and poetic ambiance, as evidenced in these lines: "A few twigs of plum blossoms by the wall / Bloom by themselves in bitter cold / One knows from a distance that they are not snow / For a delicate fragrance this way blows," "A few lonely shadows straddle the clear, shallow water." It is a good idea for the beginner to be economical with the blossoms and boughs.

Painting the petals

Use the double-outline stroke (also called nail-head rat-tail stroke, a centered-tip stroke in which the brush starts with a light downward pressure, moves along and is gradually lifted toward the end; the beginning of the stroke looks like a nail head and the ending like a rat's tail, hence the name "nail-head rat-tail"). The petals should be uniform in size. Remember to include front, side and back view blossoms. Outline the edges of the petals in pale green.

Painting the anthers

The ring of pollen dots or anthers should fall in the area where the petals overlap, not near the center; on the other hand, the dots need not touch the end of each stamen but can fall casually (Figures 1-3).

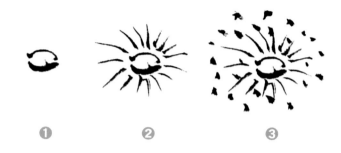

❶ ❷ ❸

Painting the calyx

Use the dotting stroke in the pattern of the letter Y, three dots to a calyx (Fig. 4).

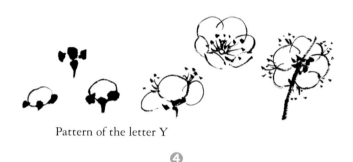

Pattern of the letter Y

❹

Painting buds

Dot the sides, not the center (Fig. 5).

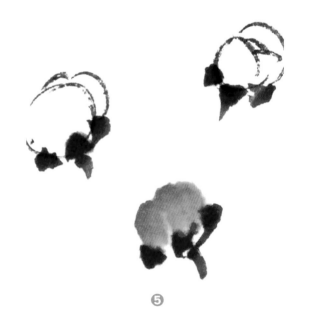

❺

When composing a plum painting, you can put in the branches and boughs before adding the blossoms; alternatively you can paint the flowers in the foreground before adding the boughs in the back (Fig. 1). The overall effect depends on both the planar arrangement and depth management. Pay attention to variation in ink tones, contrast between dry and wet brush strokes, nuanced depths and contrast in densities. These elements and factors affecting the pictorial composition need to be thoroughly studied.

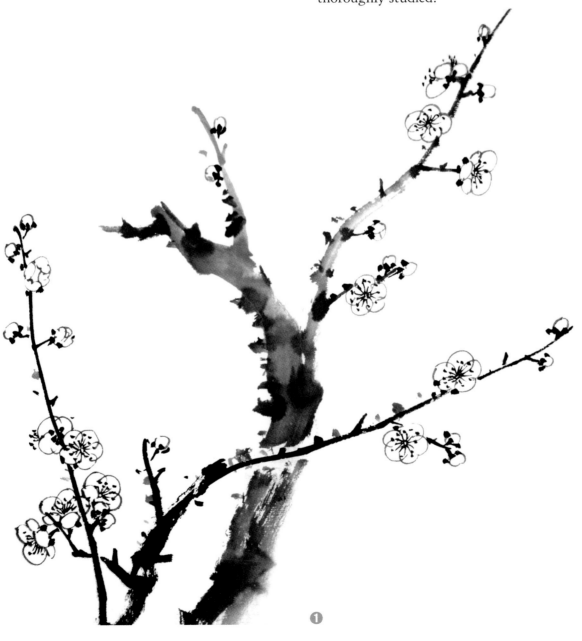

❶

Examples of painting plum blossoms

Example 1

1. Paint a bough horizontally from left to right (Fig. 1);

2. Paint a branch pointing downward (Fig. 2);

3. Draw young branches and twigs upward (Figures 3-5);

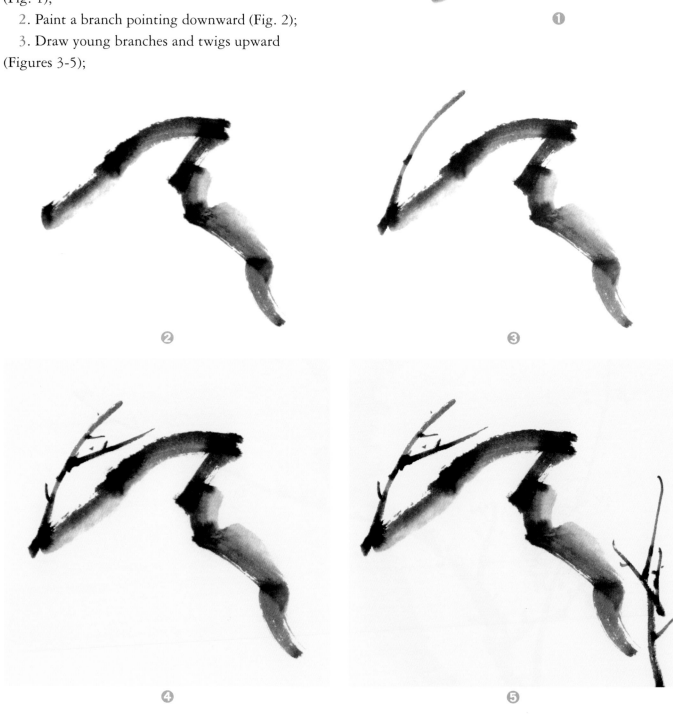

❶

❷

❸

❹

❺

4. Paint blossoms using the circling stroke (Figures 6-9);

5. Preferably complete the painting with an inscription and a seal (Fig. 10).

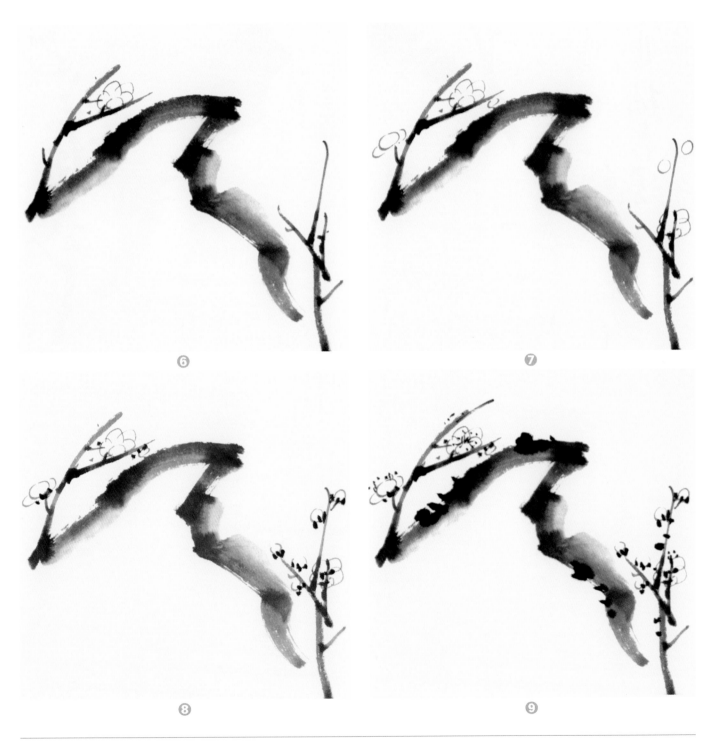

⑥

⑦

⑧

⑨

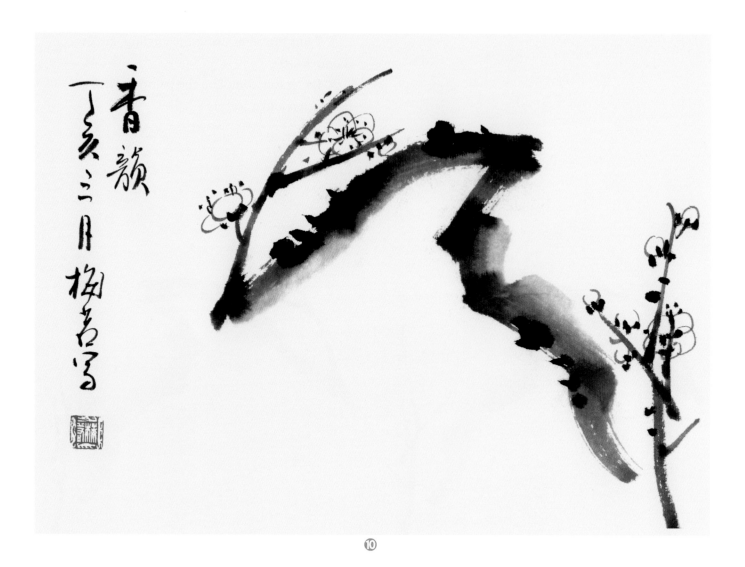

Example 2 (Figures 1-9)

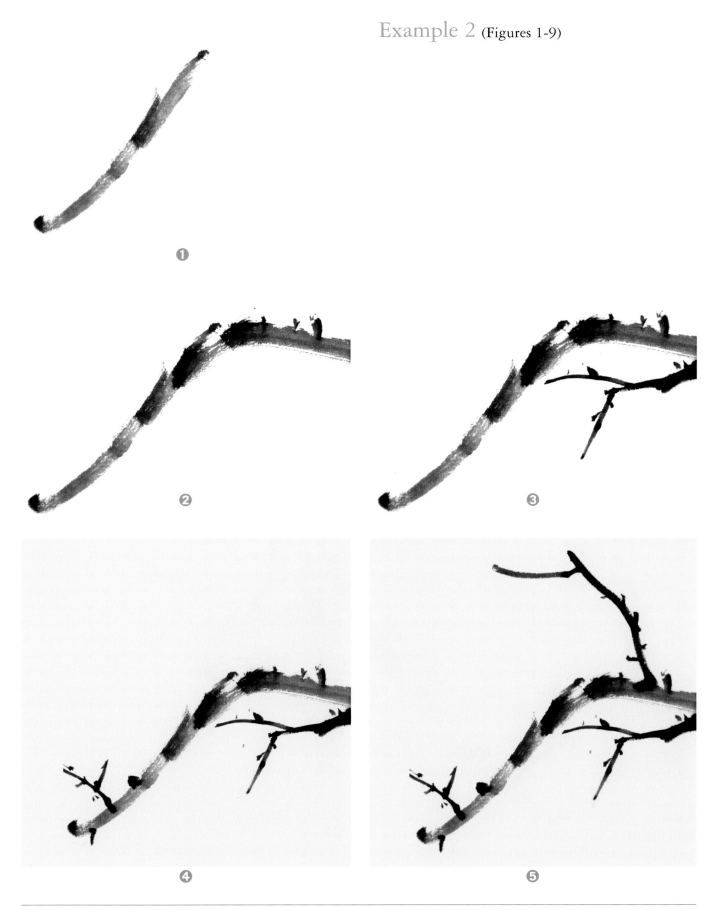

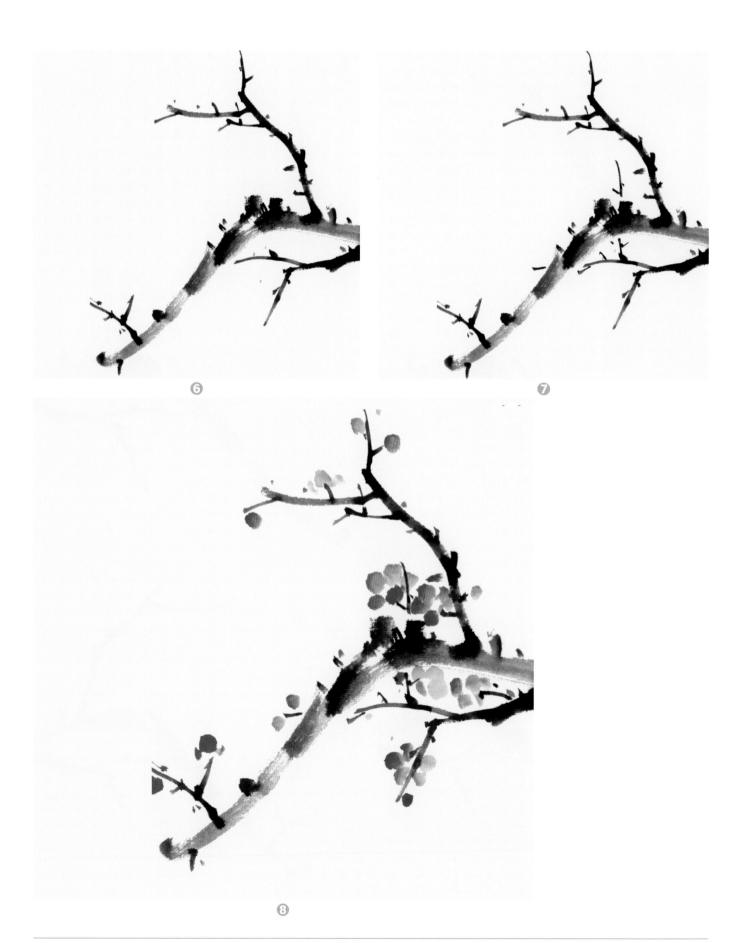

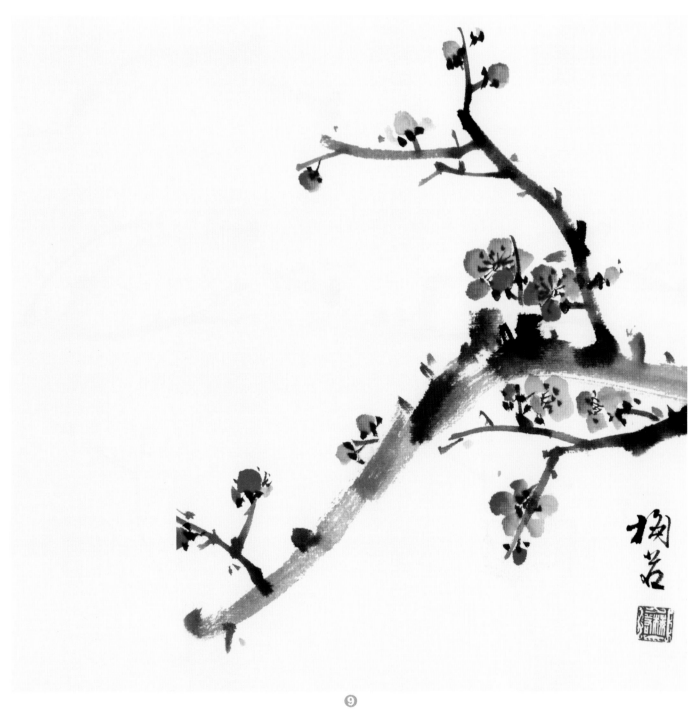

Example 3 (Figures 1-6)

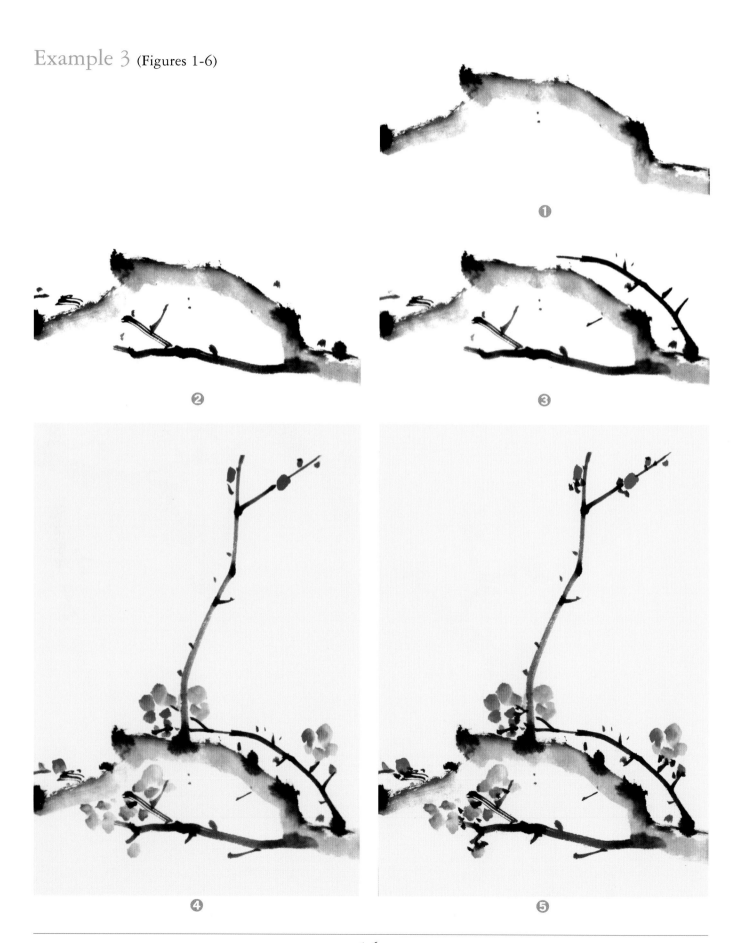

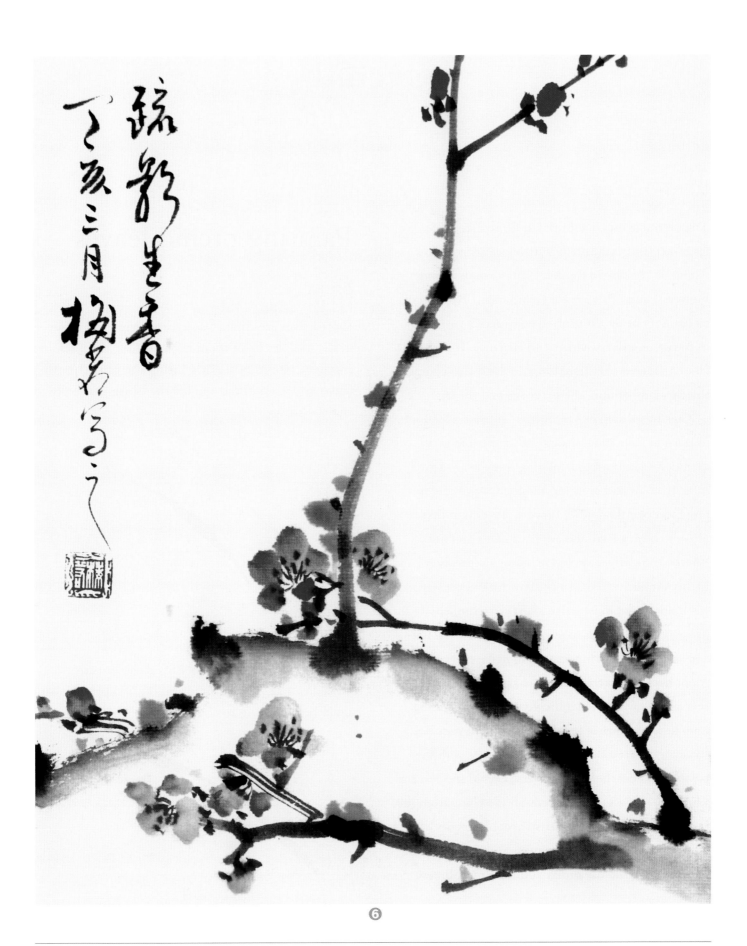

Orchid

The orchid is much admired in China. Its grace, fragrance and exquisite beauty have earned it the names of "Beauty in the Air," "Gentleman among Flowers," and "Flowers for Gentlemen." Because of its haughty beauty, it is often considered a symbol of purity, simplicity, virtue and elegance. It ranks among "the Four Elegant Ones," which also comprise the chrysanthemum, the narcissus and the iris.

Ancient wisdom in China says: "It takes a lifetime to learn to paint bamboo and half a lifetime to do orchids." Clearly orchid painting is no piece of cake. In color and in its morphology, the orchid is much simpler than other flowers; it seems at first blush to be just a combination of points and lines. But the difficulty in orchid painting lies precisely in this simplicity: it does not allow for unnecessary embroidery and must strive to excel to compensate for its spareness; it needs to impregnate the simple lines and strokes with rich meaning, to make every stroke count because botched strokes have no place to hide. It is fair to say that the difficulty of orchid painting is no less than that of bamboo painting. It requires constant observation of and acquaintance with the posture and bearing of the diverse orchid species, and a lot of practice and time spent on sketching from life.

Because of the higher artistic requirements of orchid painting, it has become an important means in training in the use of ink and brush in Chinese painting.

Painting orchid leaves

Short leaves

Short leaves are thinner at the two ends and fatter in the middle. Paint them in the centered-tip stroke: enter the stroke by slightly lifting the brush, press down as you continue and lift the brush gradually to exit the stroke (Fig. 1).

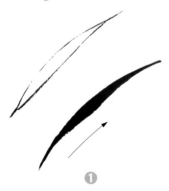

Long leaves

Enter the stroke by slightly lifting the brush, press down as you continue and lift and press down again before lifting to exit (Fig. 2).

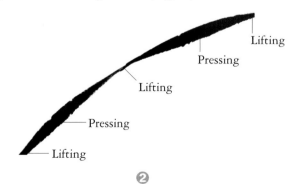

Common mistakes

Pressed and lifted too many times (Fig. 3).

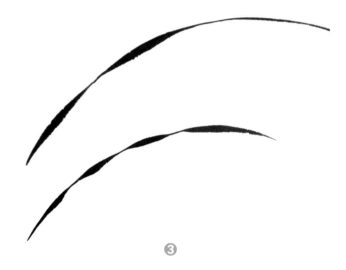

③

Lifted and pressed only once for a long leaf (Fig. 4).

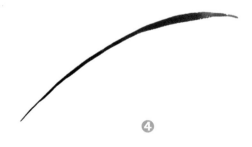

④

Pressed near the tip of the leaf (Fig. 5).

⑤

A cluster of leaves

1. The first stroke, called the *qi shou* or starter, is normally not very long.

2. The second leaf crosses the first to form what is called *feng yan* or the eye of the phoenix. Do not make the eye too small, otherwise you will have a hard time adding more leaves across it. The leaves should not quite touch at the base (Fig. 1).

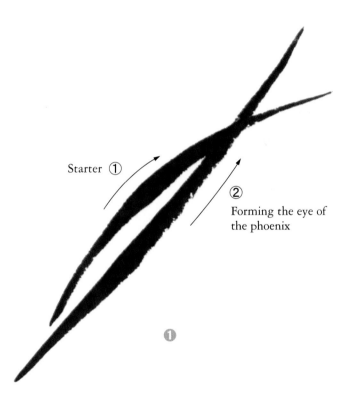

Starter ①

② Forming the eye of the phoenix

❶

3. The third, very long leaf is called the *po feng yan* or the one that breaks the phoenix eye (Fig. 2).

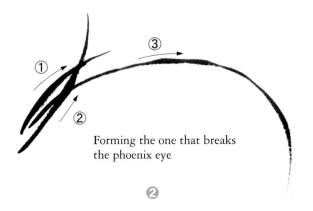

① ③
②
Forming the one that breaks the phoenix eye

❷

4. The fourth and fifth leaves are called the *fei yan* or flying swallow (converging inward but not touching at the base), like a swallow's tail (Fig. 3).

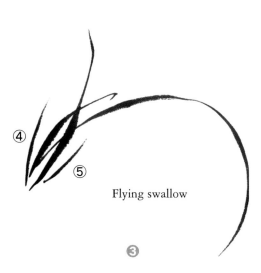

Flying swallow

❸

These five leaves constitute the basic grouping of orchid leaves (Fig. 4).

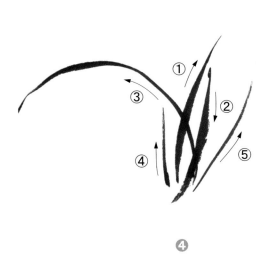

❹

5. With the fourth or the fifth leaf as the starter, you can add another cluster of five leaves. As the pictorial composition may require, you can thus paint several groups of leaves (Fig. 5).

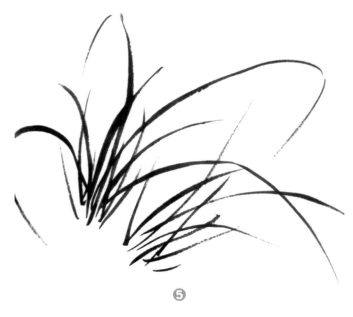

❺

6. When drawing several groups of orchid leaves, vary the lengths, sizes, thickness and directions of the leaf groups. Make sure there is variation in ink tones and that any three leaves must not cross at the same point (Fig. 6).

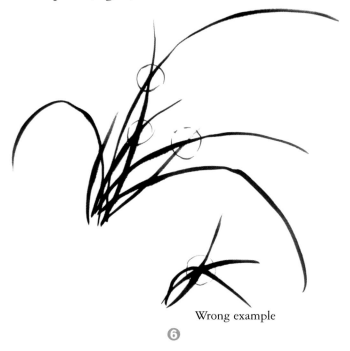

Wrong example

❻

Painting the inflorescence

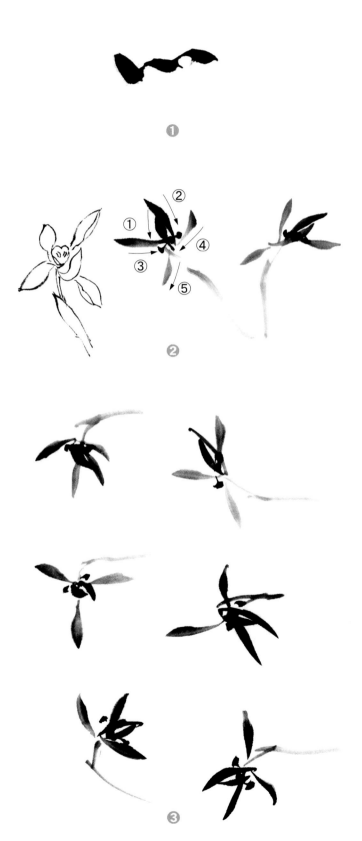

Some orchids grow one flower on each stem while others like the Cymbidium faberi bear multiple flowers on a spike. They are however structurally similar.

The accent mark of the orchid, the heart, which is much like the Chinese character " 心 " for "heart," is dotted in dark ink (Fig. 1). At the center of the inflorescence is a funnel shape, which is where the stamens and anthers are supposed to be; the five petals radiate from the center, to be painted in a variety of positions and at different angles. The strokes are similar to those used for leaves: starter stroke, phoenix eye, broken phoenix eye and the flying swallow, except that the direction of each stroke is reversed. The positions of the flowers should include full face, bending over, looking up, and looking to the right or left. Use a brush dipped in clear water, and tipped with medium shade ink (Fig. 2).

An orchid composition should have flowers pointing in different directions (Fig. 3). When painting multi-flower orchids, you can paint the flowers first before connecting them with a stem (Fig. 4).

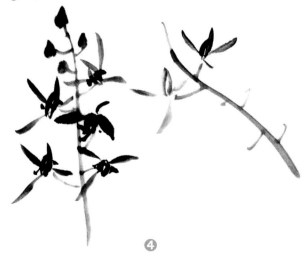

Examples of painting orchids

The following three simple examples serve as demonstrations. Practice the technique of painting orchids described above. The whole painting should preferably be enriched with calligraphy and verse inscriptions.

Example 1 (Figures 1-7)

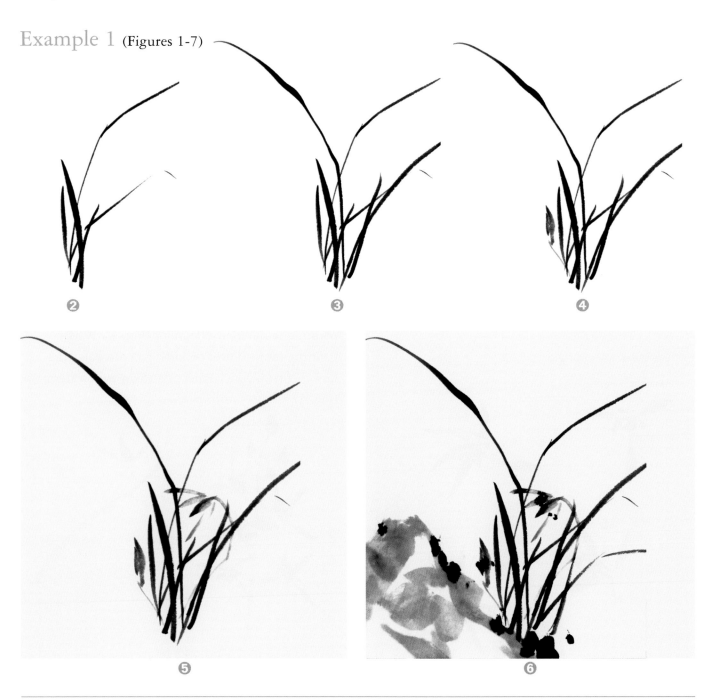

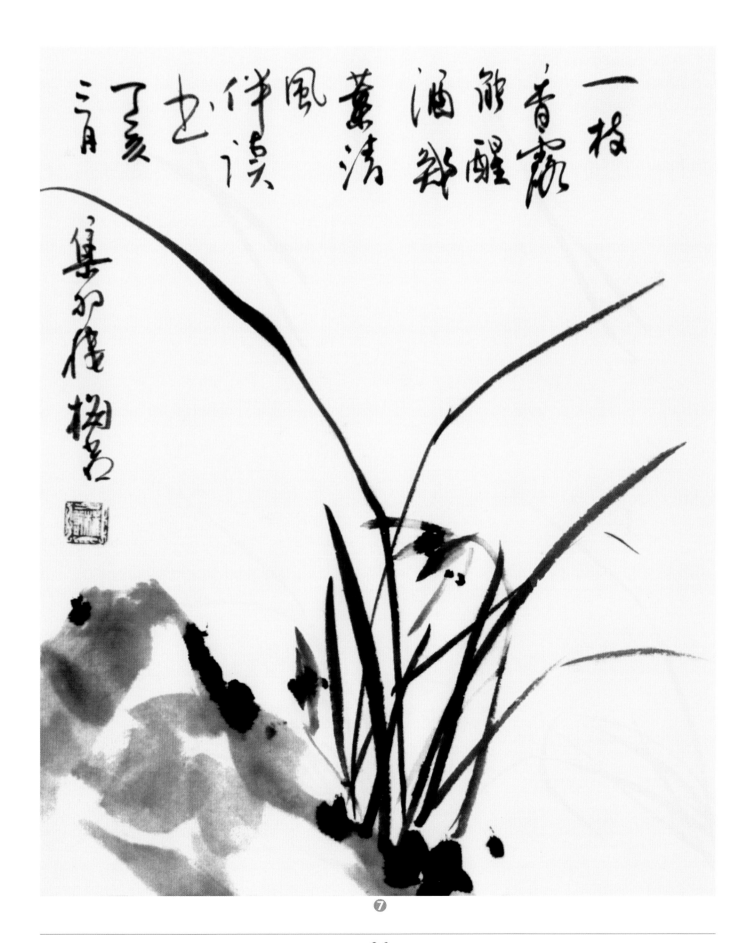

Example 2 (Figures 1-5)

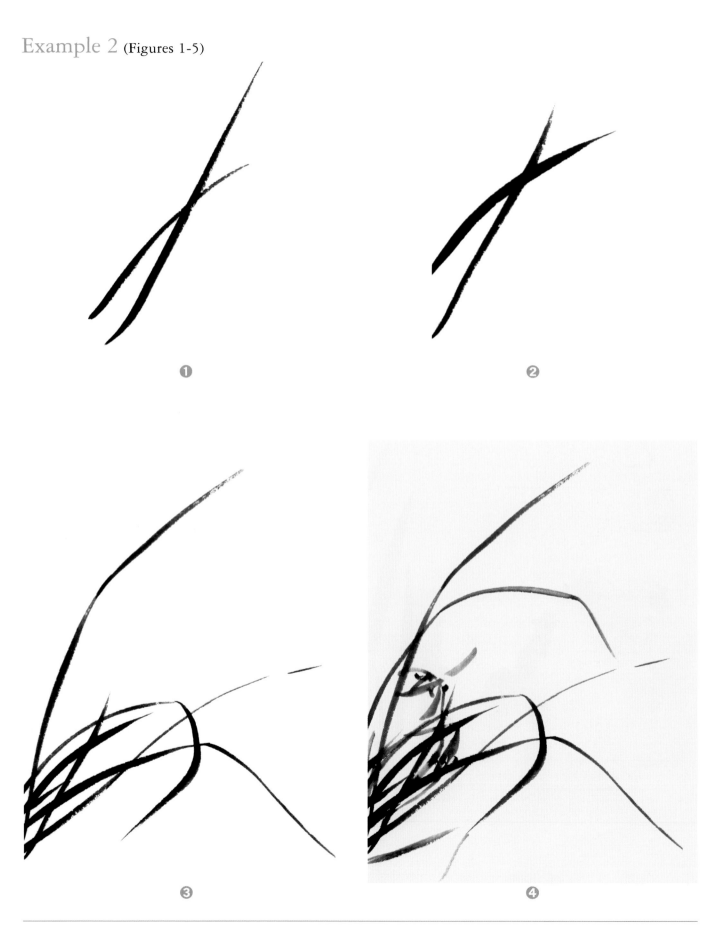

①

②

③

④

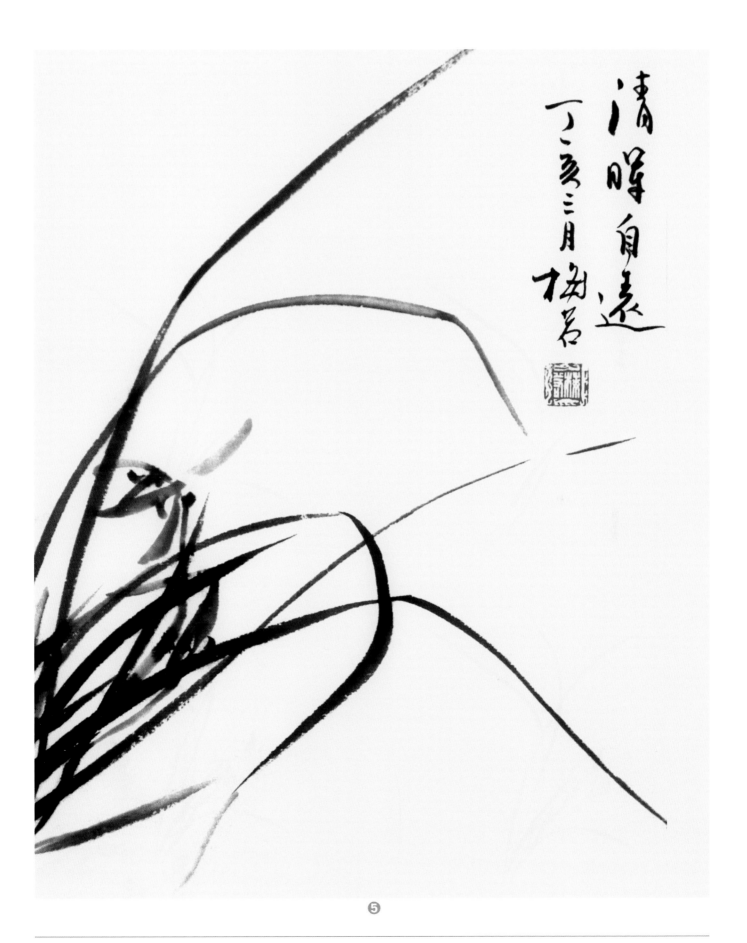

清暉自遠
丁亥三月 梅若

⑤

Example 3 (Figures 1-5)

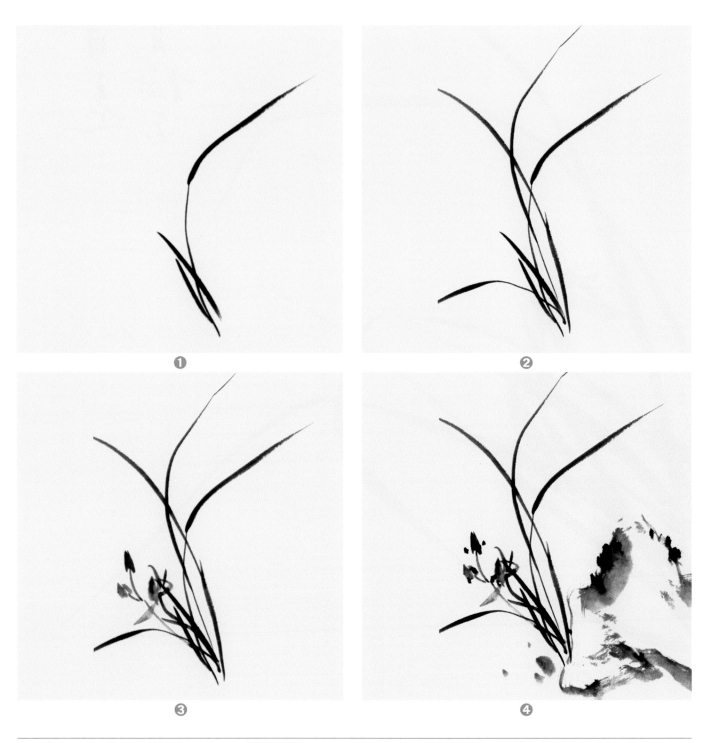

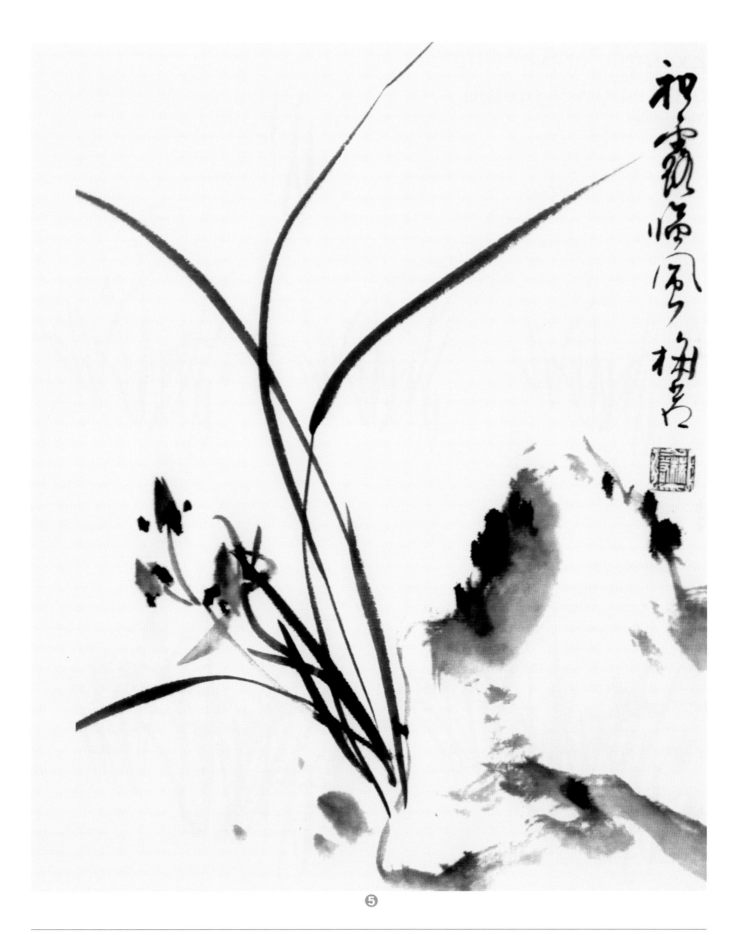

Example of painting a multi-flower orchid

(Figures 1-7)

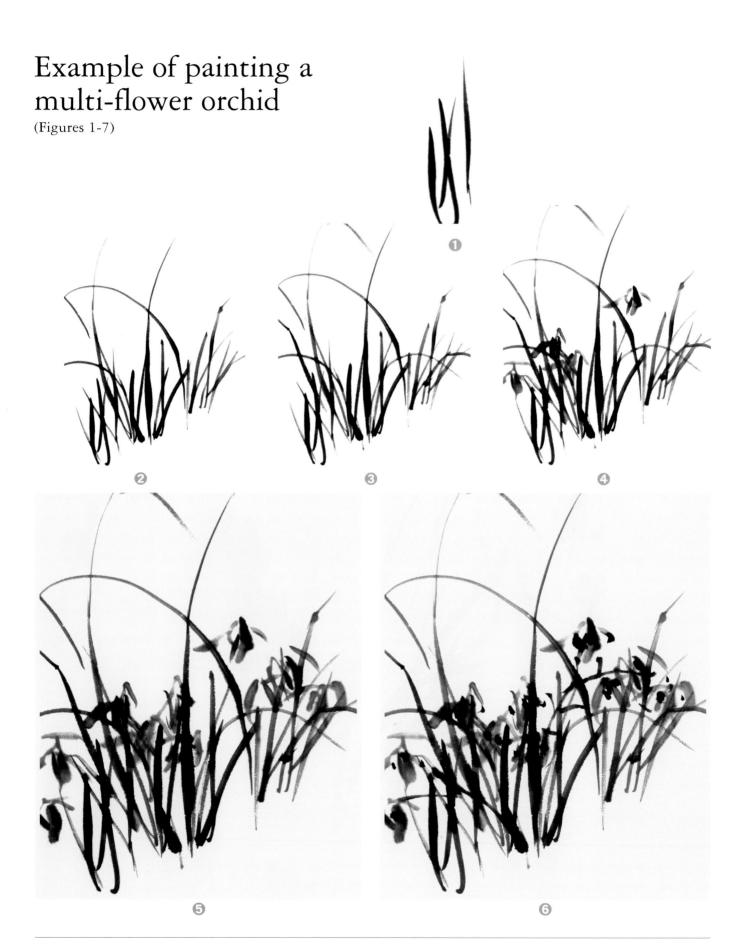

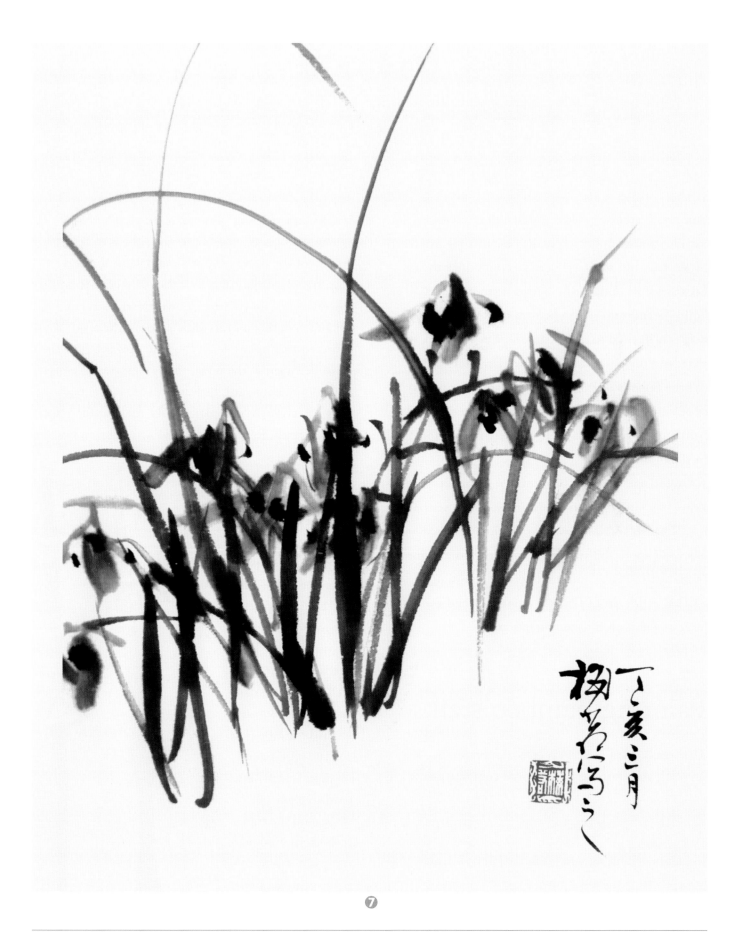

Bamboo

Bamboo is an evergreen perennial that braves extreme warm and cold conditions. It is regarded by the Chinese as a symbol of strength of character because of its nodes, which lend it strength. Its hollow stem represents open-mindedness. Its great height is likened to moral stature. The bamboo, the pine, and the plum have long been known as the "Three Friends of Winter" because of their faculty of remaining green even in the coldest weather. The bamboo has been a staple in Chinese flower-and-bird painting.

Orchid and bamboo painting is a highly developed genre in Chinese painting history, so much so that its use of brush and ink has become highly refined and has wide applicability. You go through basic training in the use of brush and ink to create "building blocks" in the art of Chinese painting when you learn to paint orchids and bamboo.

Painting bamboo stalks

The bamboo stalks serve a critical function in dividing and framing the pictorial composition.

Sequence of the strokes

In bamboo painting you normally paint the stalks first. When you paint a stalk, you need to leave blanks for the nodes between sections. There are two ways to paint a bamboo stalk: one is to start the strokes at the base of the stalk and work upward ("upstream" stroke) and the other is to start from the top and work downward ("downstream" stroke). Dip the brush in medium shade ink, move the brush in centered-tip strokes, from the base upward, flick the brush leftward at the node, slide it rightward, pause and continue upward, flick it leftward at the node, thus repeating, to complete in like manner the stalk in one breath. Reverse the steps for the top-to-bottom method.

The difference between the two stalks painted in these two methods is obvious. The stalk painted from the base upward is darker at the base and becomes paler in ink tone with height; in contrast, the ink shading on the other stalk goes from dark at the top to lighter toward the base (Fig. 1). The base-to-top method is generally used to paint tall stalks and the top-to-bottom method is more often used to paint younger stems.

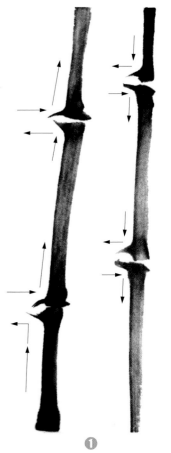

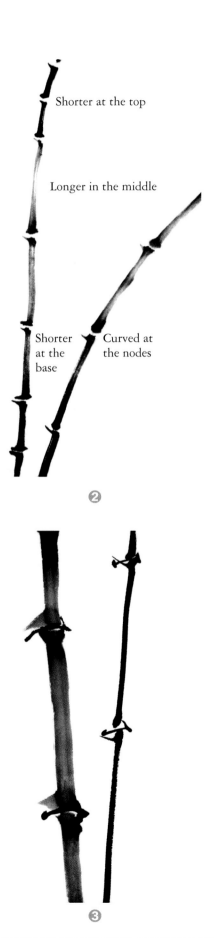

Shorter at the top

Longer in the middle

Shorter at the base

Curved at the nodes

❷

❸

The dark tone at the base of a stalk avoids a top-heavy illusion and therefore the base-to-top stroke is often employed to paint bamboo stalks. The beginner may find his/her method awkward at first. He/she can move to a more comfortable position to execute this method but should refrain from turning the paper around to ease the awkwardness because doing so would breed undesirable painting habits.

Shape

Stalk sections are shorter at the base and the top are longer in the middle. A stalk's thickness decreases from the base to the top. The stalks must not be painted too straight; instead there should be a curvature to them (Fig. 2). The length, thickness and leaning angle of the stalk sections shouldn't be varied at random. Use very black ink to the space between the sections of bamboo stalks with either of the following two strokes: one looks like the Chinese character " 乙 " and the other looks like the running script Chinese character " 八 " (Fig. 3).

Common mistakes in painting two bamboo stalks together (Fig. 4)

1. Nodes on the two stalks are placed at the same horizontal level.

2. The two stalks are parallel.

3. The two stalks are of equal thickness.

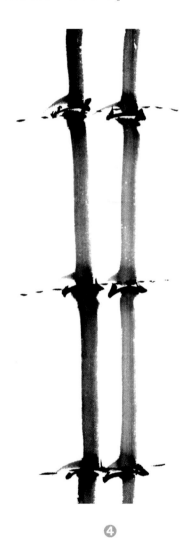

❹

Three-dimensionality

It is ill-advised to use a hard-bristle brush to paint bamboo stalks in the belief that it will better convey the toughness of bamboo; in fact the stiff hairs absorb water poorly and are ill suited to producing certain effects when painting bamboo stalks. A good choice is a brush made with more hairs in the center than on the outside. Ink flows more freely down the center but more slowly down the sparser sides, thus creating an effect of lighter ink tone down the middle of the stalk sections and darker sides, which imparts a sense of three-dimensionality to the stalks (Fig. 5).

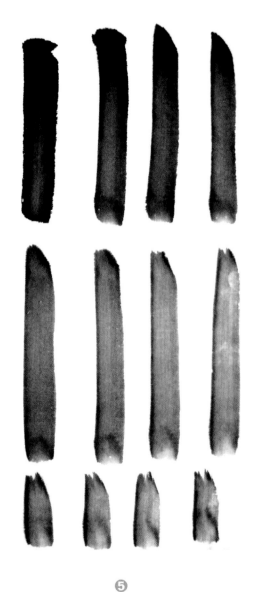

❺

Painting primary and secondary stems

The nodes between sections could be accented with dark ink. Stems should grow from alternate sides of the stalk and must not be painted only on one side (Fig. 6). After a primary stem grows out of a node (sometimes several primary stems sprout from a node), it branches out into secondary and even smaller stems. All the stems and smaller branches should be at an angle no less than 30 degrees (Fig. 7).

6

7

Painting bamboo leaves

Bamboo leaves are slim, straight and elongated. They should be painted in one resolute stroke: start with light pressure, press down further as the brush is pulled, then end by lifting (Fig. 1).

Leaves can be in the shape of a recumbent moon, a fish tail, or a goldfish tail (Fig. 1).

Groupings of bamboo leaves are often arranged in the form of the Chinese characters " 人 ," " 个 " or " 介 ." The five-stroke arrangement of leaves is also common (Fig. 2). In the " 个 " arrangement, the two outer leaves are slim and the one in the middle is fatter; in the " 介 " arrangement, the two middle strokes are thicker than the two side strokes; in the five-stroke arrangement, the three strokes in the middle are thicker than the two side ones.

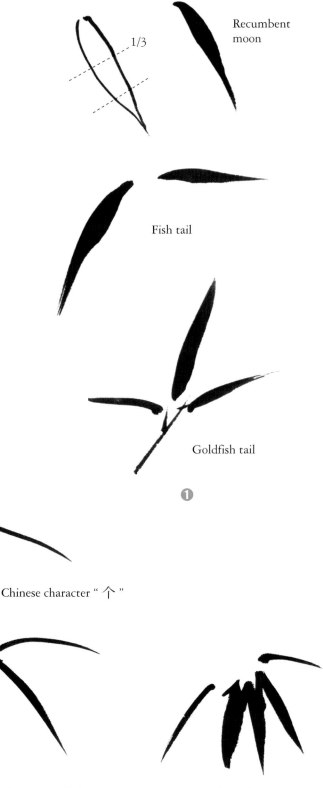

Recumbent moon

1/3

Fish tail

Goldfish tail

❶

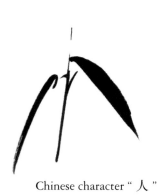

Chinese character " 人 "

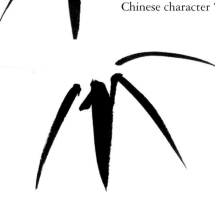

Chinese character " 个 "

Chinese character " 介 "

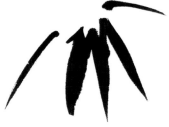

Five-stroke leaf arrangement

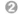

❷

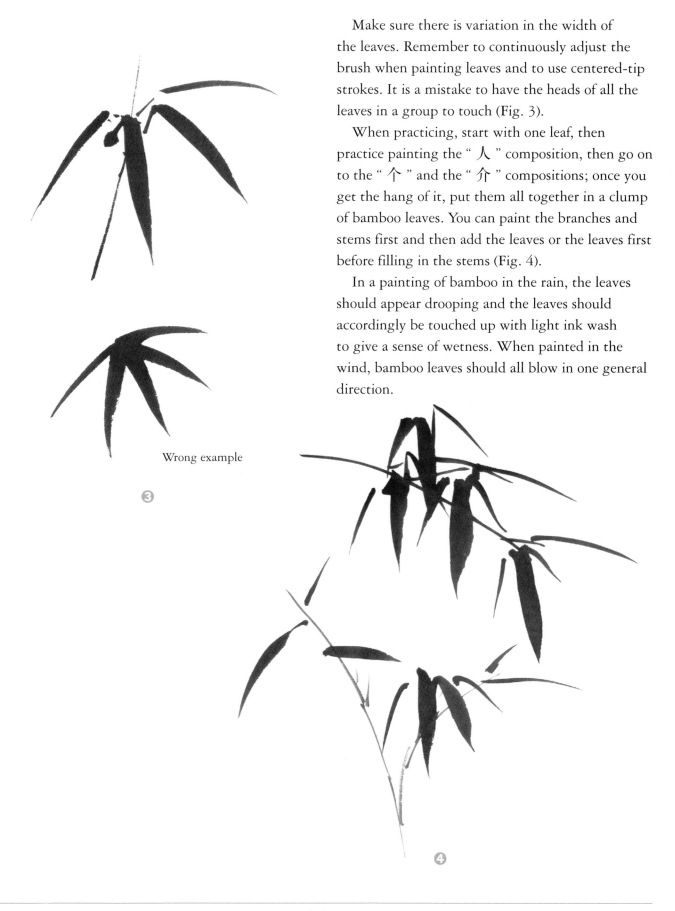

Make sure there is variation in the width of the leaves. Remember to continuously adjust the brush when painting leaves and to use centered-tip strokes. It is a mistake to have the heads of all the leaves in a group to touch (Fig. 3).

When practicing, start with one leaf, then practice painting the " 人 " composition, then go on to the " 个 " and the " 介 " compositions; once you get the hang of it, put them all together in a clump of bamboo leaves. You can paint the branches and stems first and then add the leaves or the leaves first before filling in the stems (Fig. 4).

In a painting of bamboo in the rain, the leaves should appear drooping and the leaves should accordingly be touched up with light ink wash to give a sense of wetness. When painted in the wind, bamboo leaves should all blow in one general direction.

Wrong example

❸

❹

Common mistakes

1. Lack of transition and variation of ink tone in a clump of leaves.
2. Pale strokes amid dark ones or vice versa (Fig. 5).

To ensure ink tone variation, after painting the bamboo stems, use a brush dipped in clear water and tipped with dark ink to begin painting leaves, starting from the tip of the stem; as you work down the stem, the ink at the tip of the brush becomes thinner, until it dries; continue by dipping the brush in clear water. Then the leaves will show a variation in ink tonality and the composition will look more natural (Fig 6). A clump of bamboo leaves should not be painted too slack, nor should it be too compact.

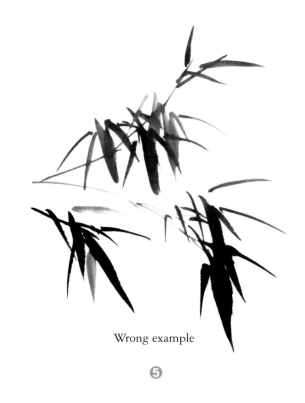

Wrong example

⑤

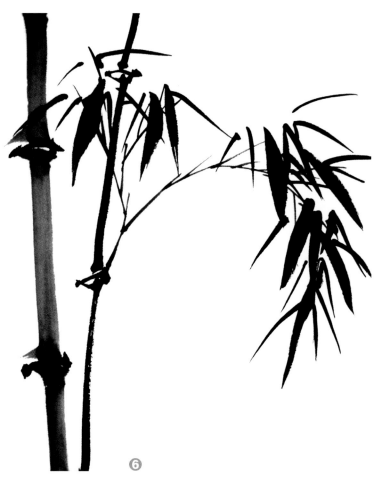

⑥

Examples of different compositions of a bamboo painting

Example 1 (Figures 1-10)

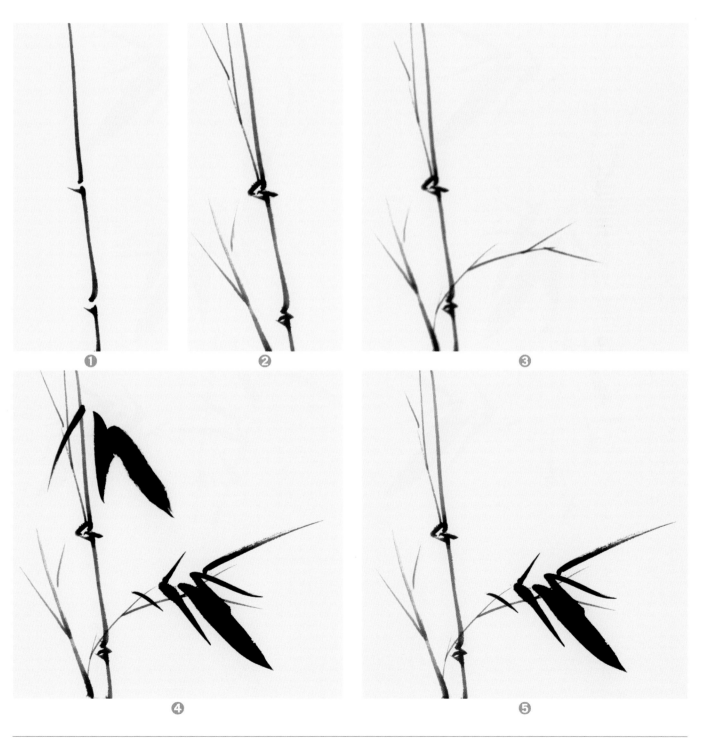

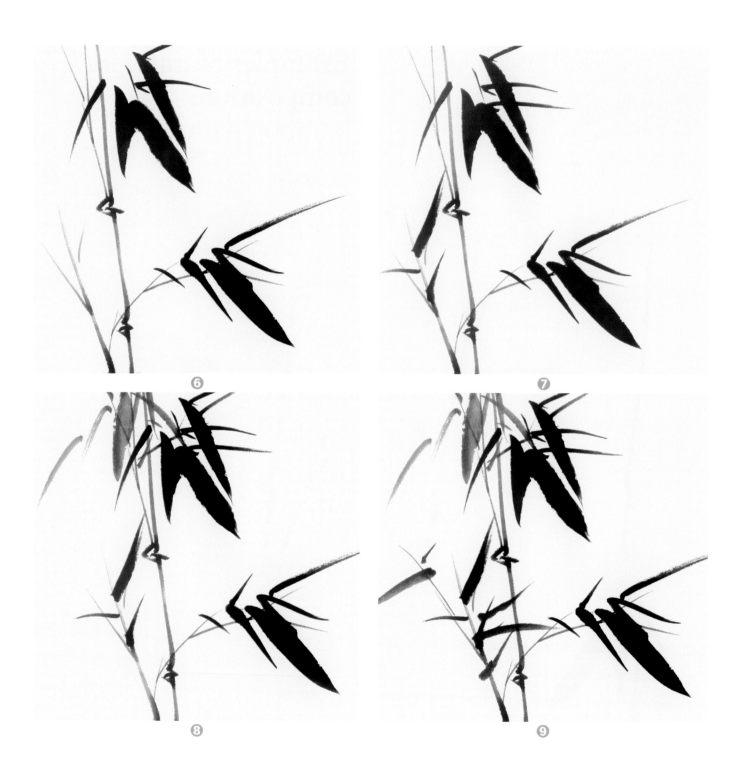

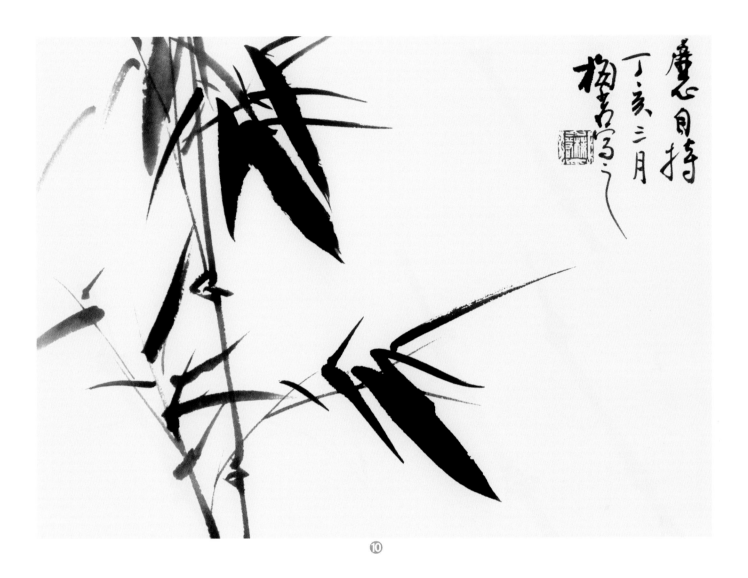

Example 2 (Figures 1-10)

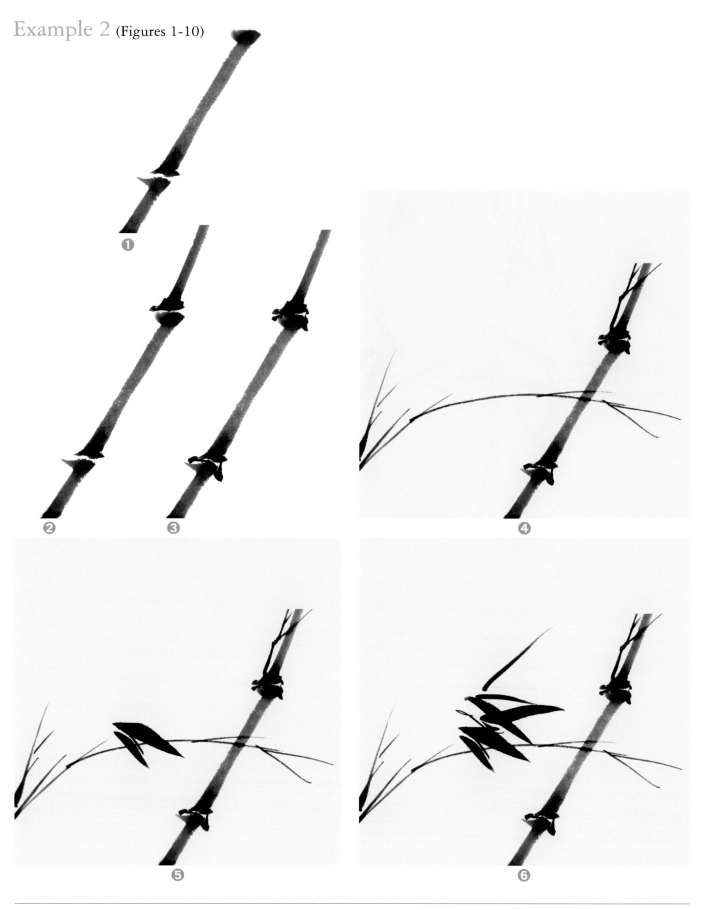

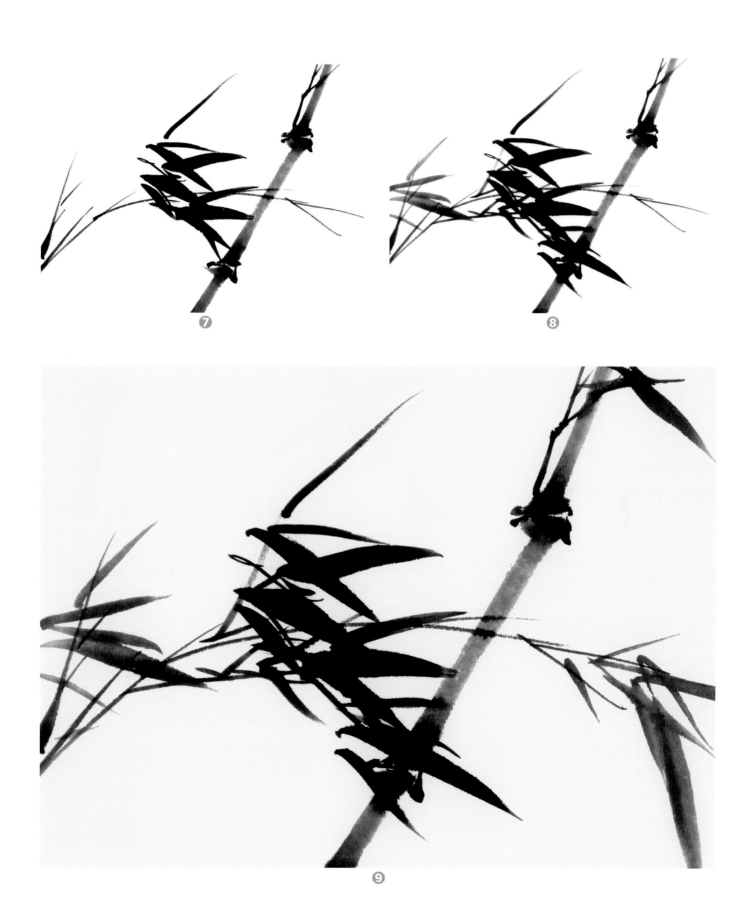

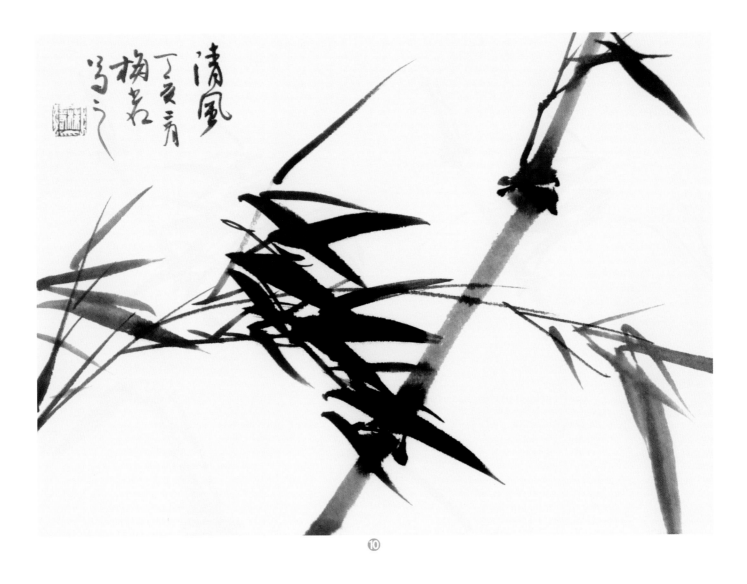

Example 3 (Figures 1-8)

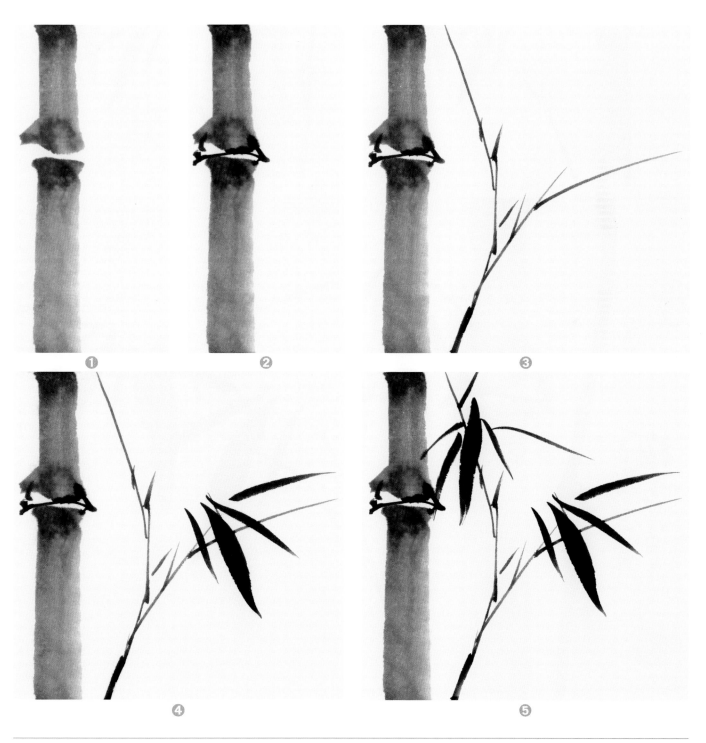

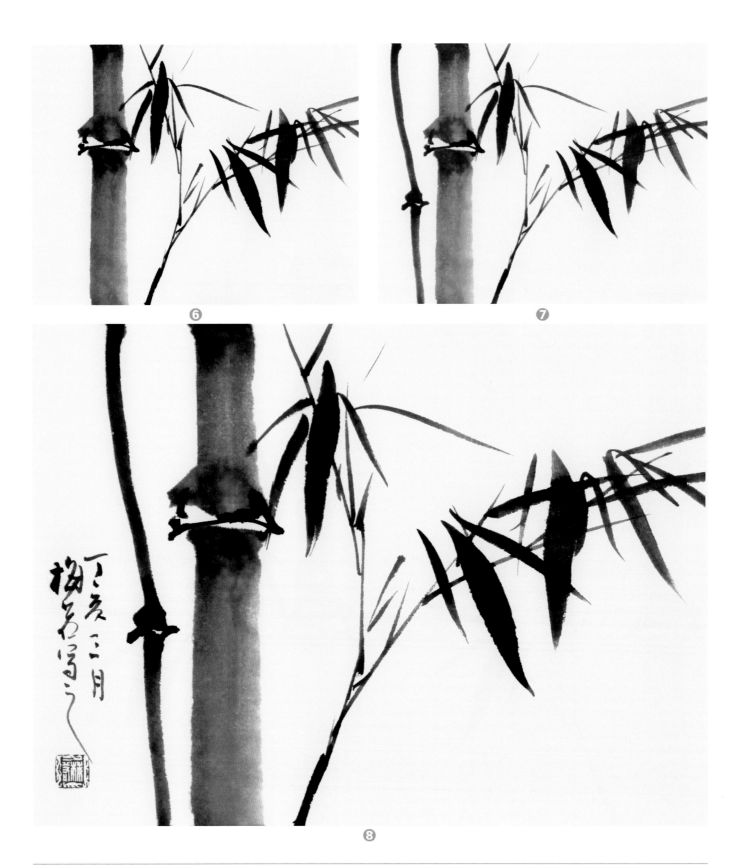

Example of bamboo in the rain

After completing the bamboo, sprinkle water before the painting dries, to create the effect of wetness (Figures 1-10).

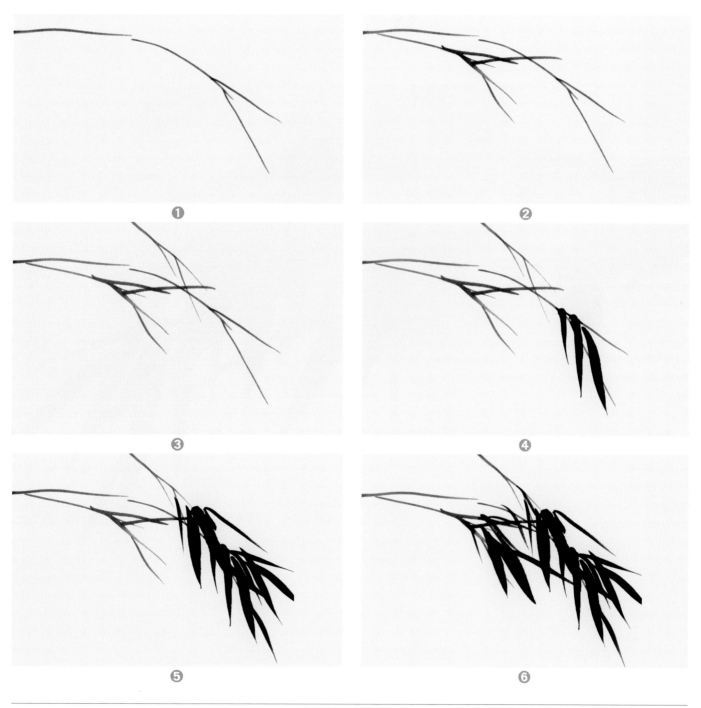

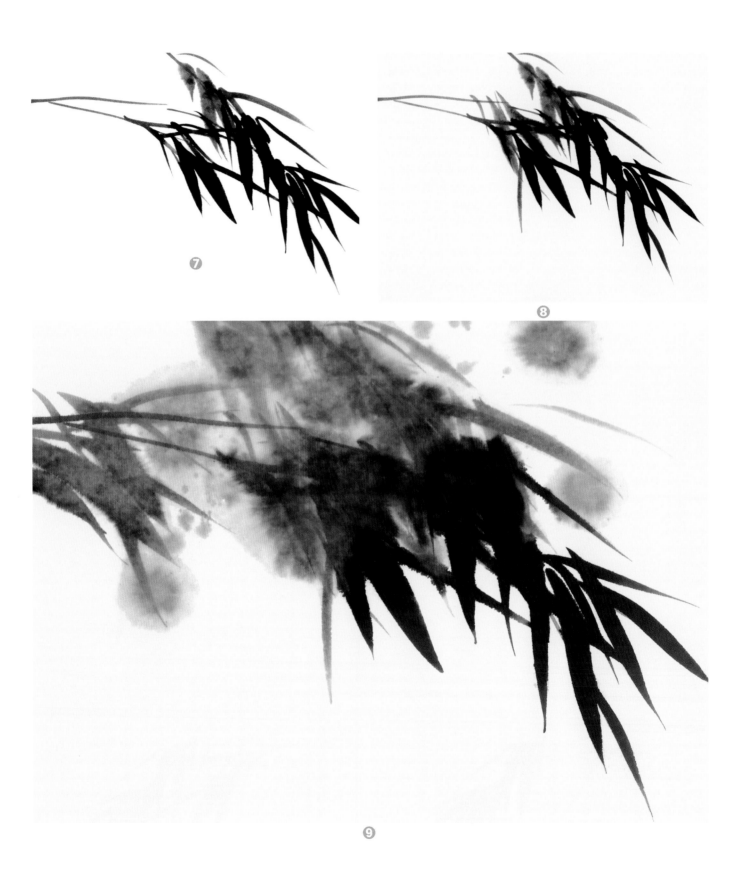

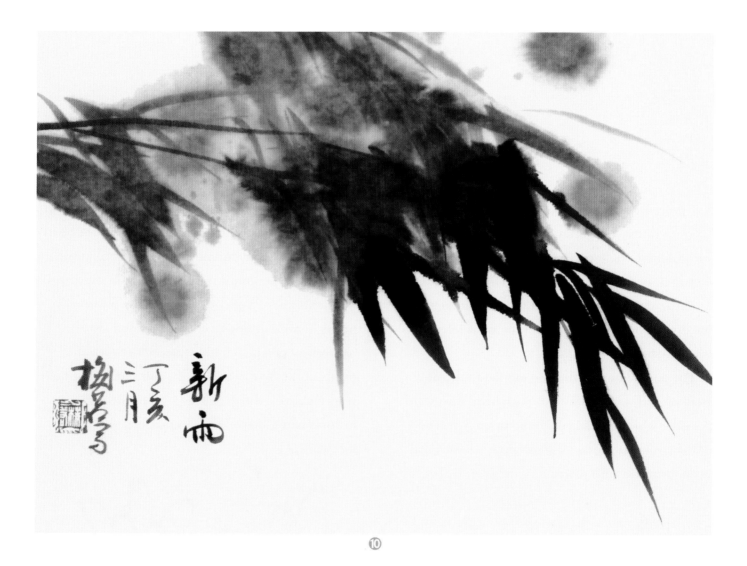

⑩

Chrysanthemum

The graceful chrysanthemum comes in a colorful, fragrant variety of species. It is deeply associated with Chinese tradition. To capture its rich diversity on paper, practice in drawing from life is essential.

There are two ways to paint the chrysanthemum: the double-outline method and the *xie yi* ink and wash method.

The double-outline method employs the nail-head rat-tail stroke that starts with light downward pressure which is gradually lifted toward the end of the stroke. It characteristically starts with a nail head form and ends with a rat's tail (Fig. 1). In

flower first; then use the nail-head rat-tail stroke to double outline eight to nine petals around the heart (the stroke used to outline the petals should trail out to a fine line and must not be uniform in thickness).

The flower of a chrysanthemum has numerous petals in overlapping layers. The second layer or circle of petals should be placed between the petals of the first layer (Fig. 2), and should not be placed above them as in Fig. 3. Paint the petals in contrasting shapes and orientations to avoid a mechanical look.

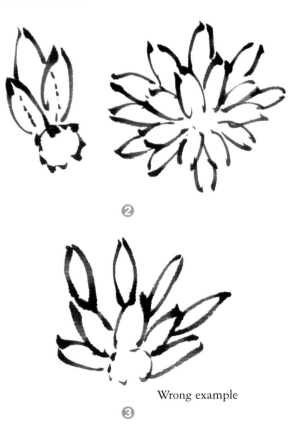

Double-outline method

Wrong example

②

❶

③

Wrong example

the double-outline method, the chrysanthemum petals are outlined, but not with a very small brush, because it picks up less ink. Paint the heart of the

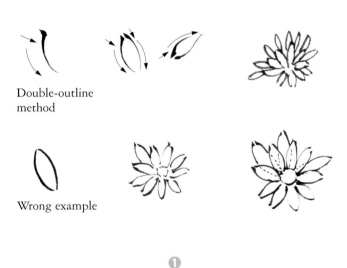

Various stages of growth

In bud; in partial bloom (asymmetrical); in full bloom and oriented downward (Fig. 4).

In bud

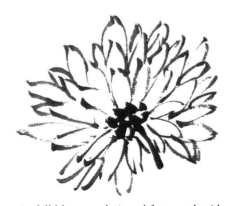

In full bloom and oriented downward

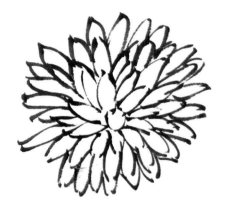

In partial bloom (asymmetrical)

④

Views from different angles

Frontal; Pointing downward; sideways; viewed from above; viewed from underside (the sepals need to be painted in this case) (Fig. 5).

Frontal

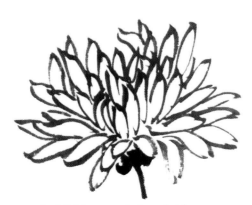

In full bloom and viewed sideways

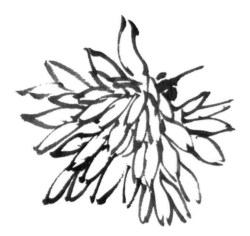

In full bloom and viewed from underside

⑤

Painting a chrysanthemum with slender petals

1. Paint the flower head in double-outline strokes, with slim, long lines.

2. Finish the strokes in good time so that you can apply yellow before the ink dries. This is to ensure that the color applied on the wet ink will bleed to bring out the wet dark ink for effect (Fig. 1).

Pay attention to variation in ink tone and wetness. This is accomplished by using a brush soaked to its base with clear water and tipped with a little dark ink. Starting from the center, continue to paint circles of petals outward (normally three circles or more). The ink becomes thinner and dryer as you get to the outer circles. The result is a chrysanthemum flower that seems to come alive with nuances of ink tone and wetness (Fig. 2).

Painting a chrysanthemum in color

Dip the brush in clear water, then in gamboge and tip it with a little orange red; color the flower from the center outward, the color becoming paler gradually (Fig. 3).

Common mistakes (Fig. 4)

1. The petals are painted with disjointed lines;
2. Color is not applied satisfactorily.

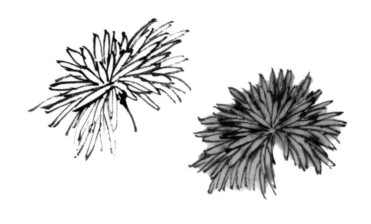

❶

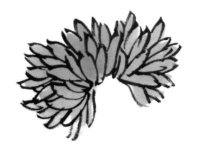

Variation in ink tone and wetness

❷

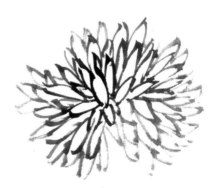

❸

❹

Painting a chrysanthemum in the *xie yi* style

Xie yi, literally "writing ideas," is an important style in chinese painting characterized by a free flowing, spontaneous minimalism.

It is important to properly tip the brush with colors: dip the brush first in clear water, then pick up four separate colors gamboge, orange red, eosin and rouge in that order (Fig. 1). Paint in centered-tip strokes from the center outward. The nuanced colors will impart a sense of three-dimensionality to the flower.

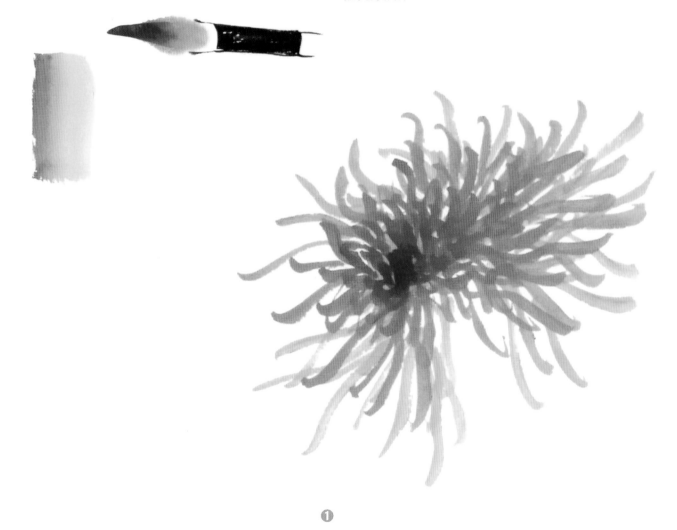

❶

Painting chrysanthemum leaves in the ink wash *xie yi* style

1. Each leaf has five oblong lobes, unlike leaves on most other flower plants. When painting chrysanthemum leaves, carefully choose the right size brush. Color with a green made by mixing gamboge and cyanine. Press down on the brush so that the base of the brush is close to the paper surface and finish painting a leaf in six strokes (Fig. 1).

2. Paint the leaves in different orientations and at different angles (Fig. 2).

3. You can outline the veins on the leaves in thicker lines; make sure they are pleasing to the eye (Fig. 3).

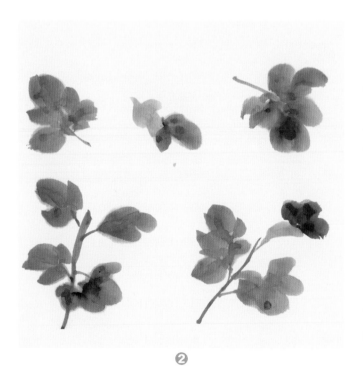

❶

❷

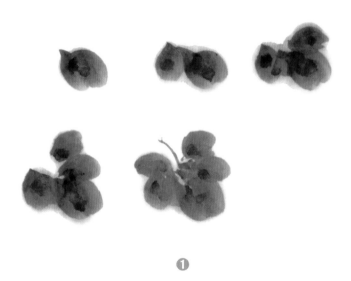

❸

Examples of painting chrysanthemum

Example 1 (Figures 1-12)

Double outline a flower, dot the sepals in olive green. The main stem should be curved and not straight. Paint the leaves with a brush in a mixture of gamboge and cyanine and tipped in ink. Paint the leaves near the flower head first, adding some more before outlining the leaf veins in dark ink. Color the flower head in gamboge before the ink dries (Figures 1-12).

①

②

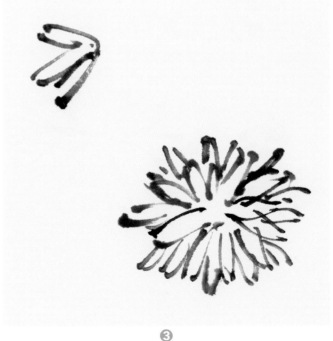

③

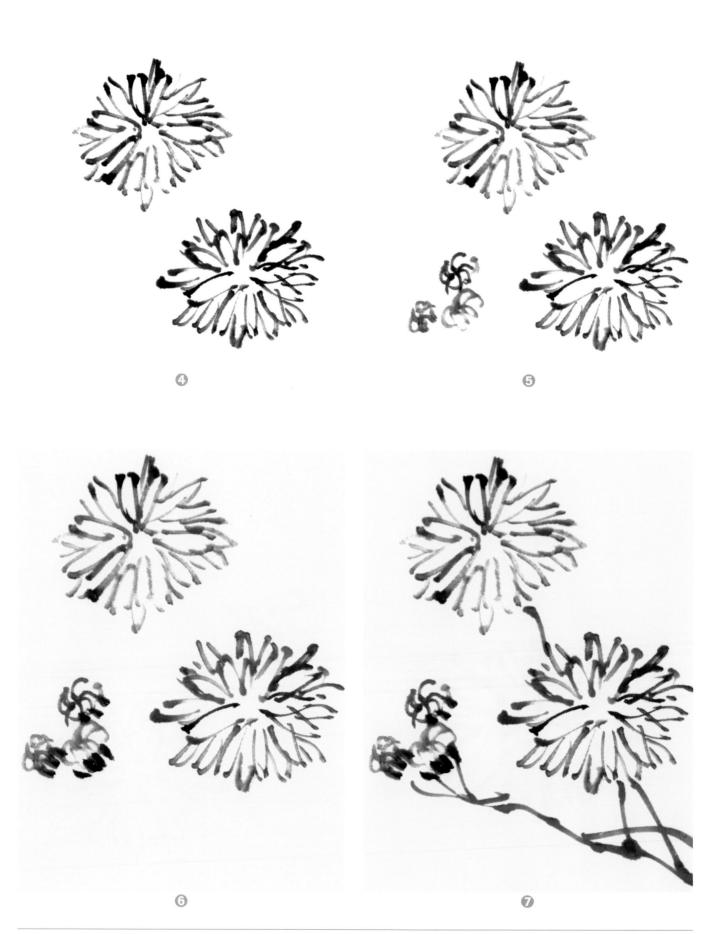

④

⑤

⑥

⑦

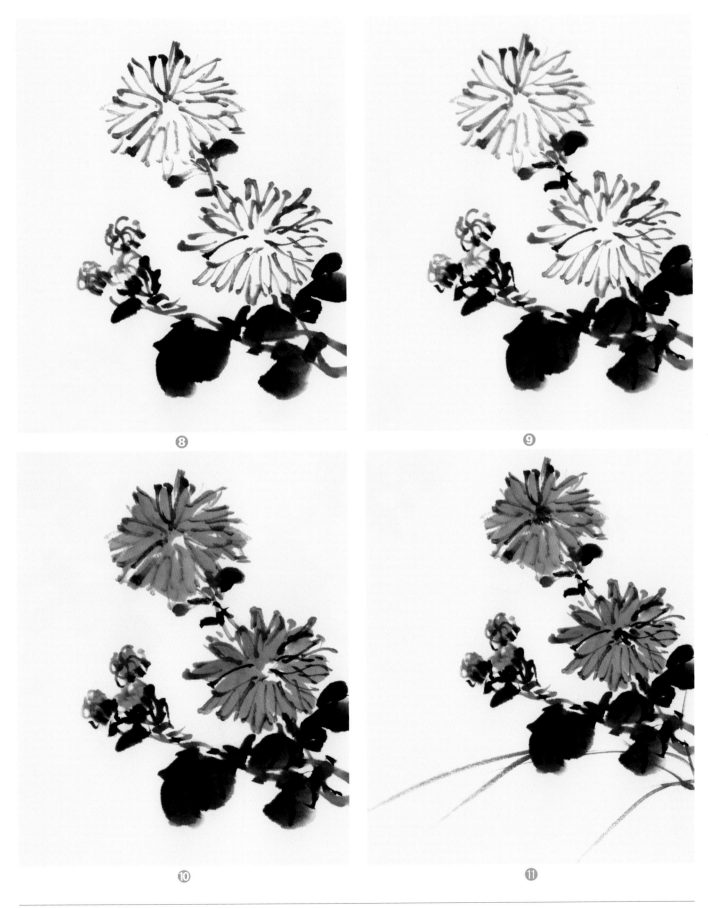

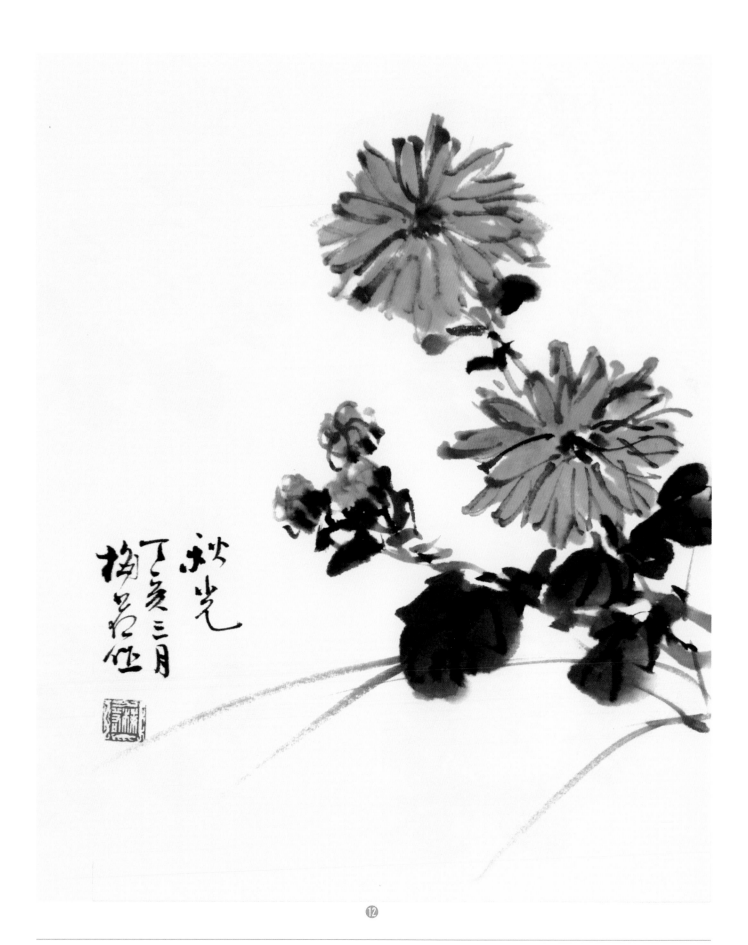

Example 2

Chrysanthemum by a rock; the rock is colored in gamboge also (Figures 1-9).

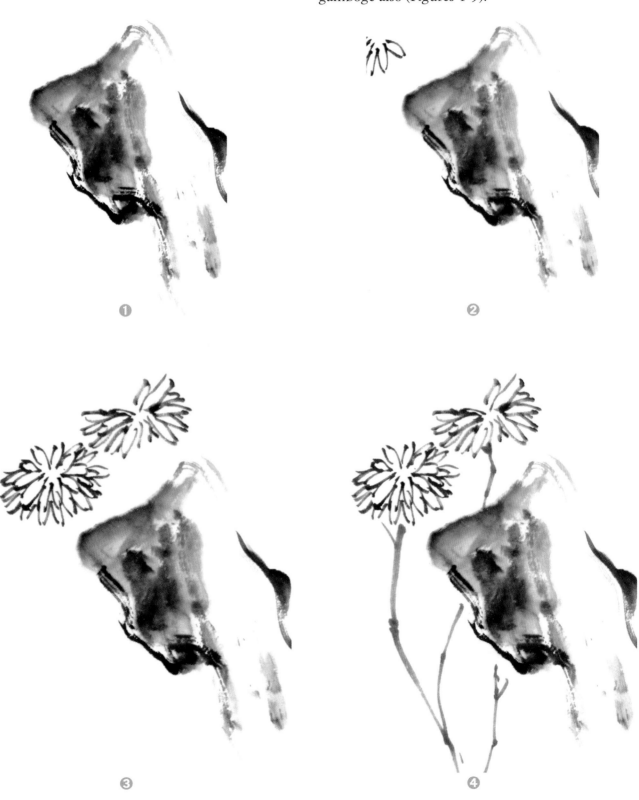

①

②

③

④

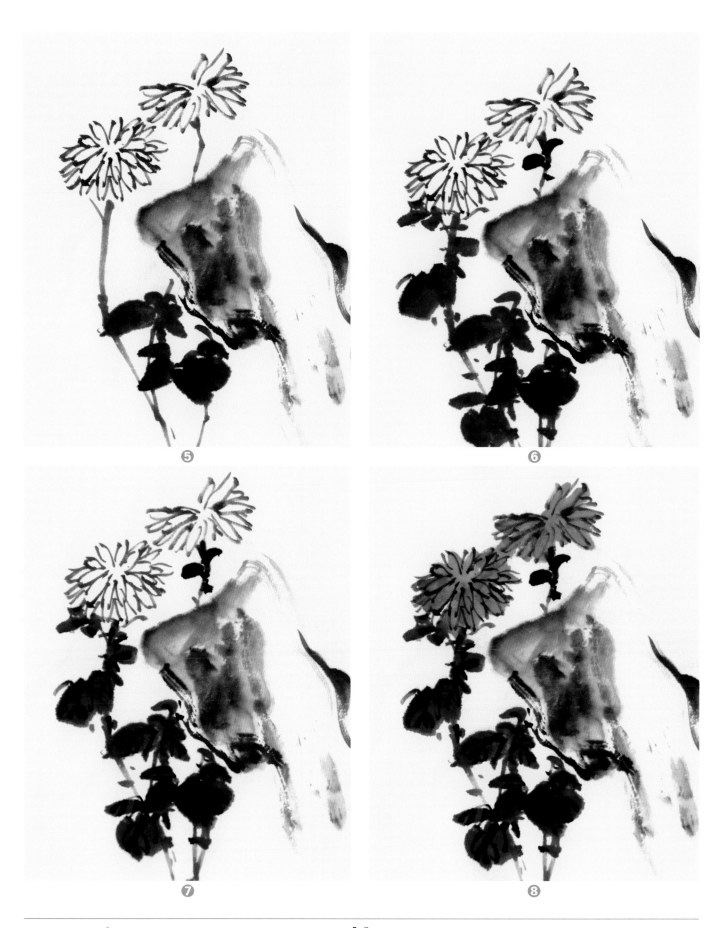

⑤

⑥

⑦

⑧

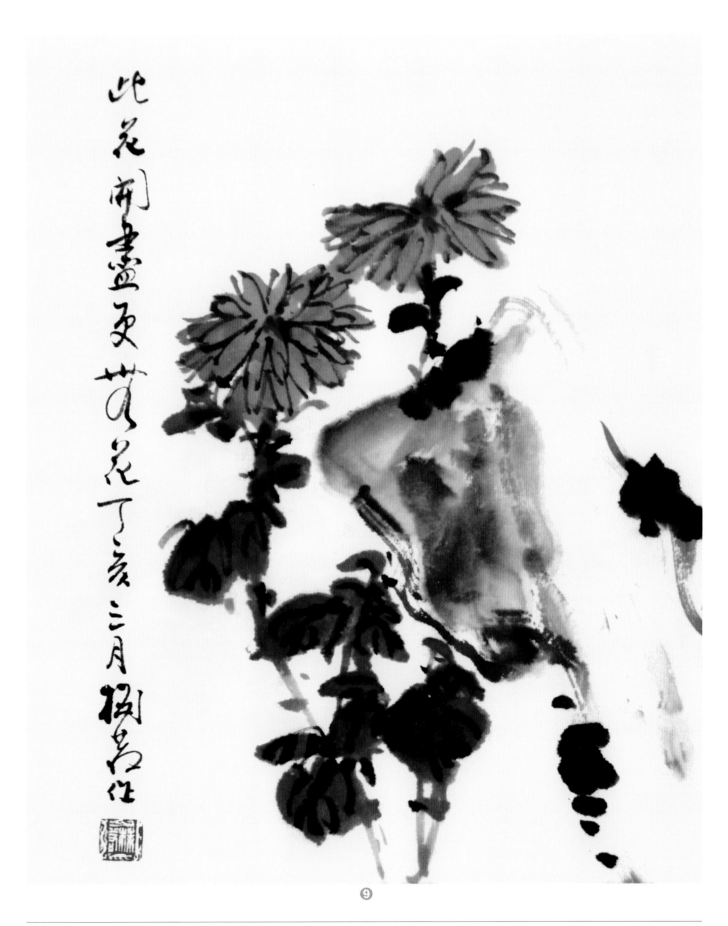

此花開畫盡更芟花丁亥二月楓昌作

Example 3

Chrysanthemum in color in the *xie yi* style; Paint
the leaves as described above (Fig. 1).

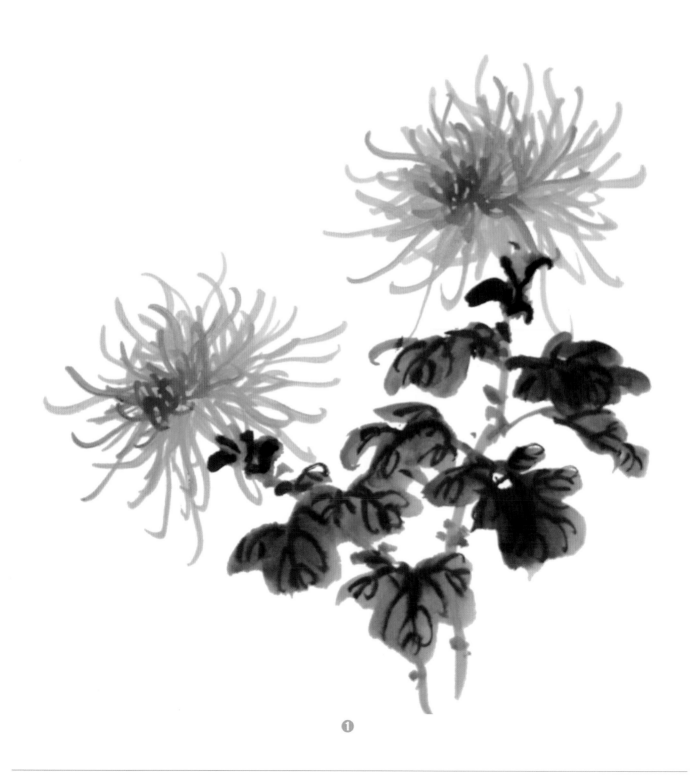

❶

Appendices

Materials and Equipment for Chinese Painting

I. Brush

A Chinese painting brush can have soft or hard hairs or a combination of them. The brushes are made in large, medium and small sizes. The soft-hair brushes, generally of goat hairs, are very absorbent and suitable for dotting leaves and coloring. Wolf hairs make a hard brush that is tough and flexible and good for outlining leaf veins and tree trunks, among other uses. The combination brush is made of wolf and goat hairs.

The brush is composed of the tip, the "belly" (midsection), and the base (near the shaft).

II. Ink

Chinese painting is mainly done in ink, which is made from either lampblack or pine soot. Lampblack is darker, shinier and more suitable for painting. Pine soot is flatter and more suitable for calligraphy. In the past artists used to grind their ink sticks to make ink for their paintings; nowadays most artists prefer bottled ink. Choose the ink specially made for painting and calligraphy, otherwise the ink will fade after the painting is framed.

III. Paper

The paper used for Chinese painting is called *xuan* paper (also rice paper). There are two kinds of *xuan* paper: the mature *xuan* paper, which is treated with alum to make it less absorbent, good for the detailed style of Chinese painting because you can apply many coats of colors without fear of undesirable blending; and the raw *xuan* paper, which is untreated and absorbent, and suitable for the *xie yi* style because the blending of ink and color can be used by artists to produce nuanced ink tones.

IV. Inkstone

The inkstone used for Chinese painting is made from aqueous rock, which is hard and fine-textured and produces dense ink

when ground. The *Duan* inkstone, made from stone quarried in Duanxi in Guangdong Province, is the most famous of the inkstones in China. But people have turned to the more convenient bottled ink, which produces equally good results.

V. Pigments

The pigments used for Chinese painting are different from those used in western painting, and have different names. Pigments can be classified as water soluble, mineral or stone. Gamboge, cyanine, phthalocyanine, eosin and rouge are some of the water soluble paints; mineral paints include beryl blue, malachite, cinnabar and titanium white. Ocher comes under the "stone" rubric.

VI. Accessory equipment

Water bowl for rinsing brushes, felt table cover, palette etc.

Use of Ink and Brush in Chinese Painting

I. Using brush

Any stroke used in Chinese painting comprises three stages: entering the stroke, moving the brush along and exiting from the stroke. Some of the strokes are *zhong-feng* (centered-tip), *ce-feng* (side-brush), *shun-feng* ("slant-and-pull-away-from-brush-tip" or "downstream"), *ni-feng* ("slant-and-push-into-brush-tip" or "upstream"), *ti* (lift), *an* (press), *dun* (pause) and *cuo* (twist-around) etc.

The centered-tip stroke moves along the center of the ink line with the tip of the brush. To execute the side-brush stroke, the brush is held at an angle, with the tip against one side of the line (point or surface), and moves with its "belly" pressed against the paper (Fig. 1). The *shun-feng* stroke is used to paint from top downward or from left to right, while the *ni-feng* stroke moves from the bottom upward or from right to left. "Lifting" the brush as it pulls along will make a lighter line. "Press" down on the brush to make a thicker and darker line. The *dun* stroke consists in pressing the brush into the paper or grinding and rotating the brush. Several *dun* strokes constitute a *cuo* stroke.

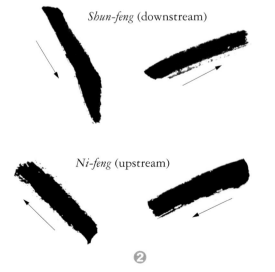

Zhong-feng (centered-tip)

Ce-feng (side-brush)

❶

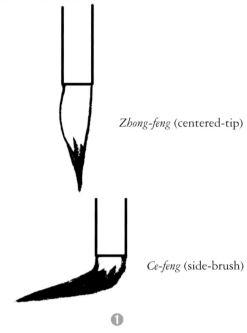

Shun-feng (downstream)

Ni-feng (upstream)

❷

II. Using ink

In Chinese painting it is important to master the use of the following five gradations of ink: dark, light, dry brush, wet brush and charred (burnt).

Dark ink: Add a small amount of water to the ink to make a dark shade;

Light ink: Increase the amount of water in the mixture to make a grayish ink;

Dry brush: A brush that contains only a small amount of water can apply either dark or light ink;

Wet brush: The brush contains more water and can also apply either dark or light ink;

Charred ink tone: Very black shading that creates a shiny black effect on the paper (Fig. 3).

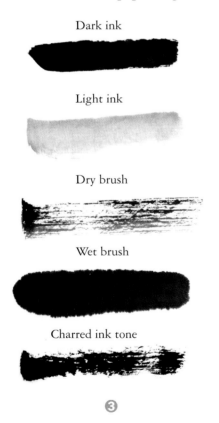

Dark ink

Light ink

Dry brush

Wet brush

Charred ink tone

❸

III. Brush and ink

Brush and ink are mutually reinforcing. The use of ink is just the other side of the brush use.

The wetness or dryness of the ink translates into the wetness or dryness of the brush to communicate the "spirit of the ink." The use of ink and the use of the brush are closely interdependent.

It is important to bear in mind these six words when using the brush: *qing* (light), *kuai* (fast), *ce* (side), *zhong*1 (heavy), *man* (slow), *zhong*2 (center).

Qing: Lifting the pressure on the brush while the stroke is in progress;

Kuai: Shortening the time of the stroke;

Ce: Using the *ce-feng* (side-brush) stroke;

*Zhong*1: Pressing down on the brush while the stroke is in progress;

Man: Increasing the time of the stroke;

*Zhong*2: Using the *zhong-feng* (centered-tip) stroke (Fig. 4).

Qing	*Zhong*1
Kuai	*Man*
Ce	*Zhong*2
Dry	Wet

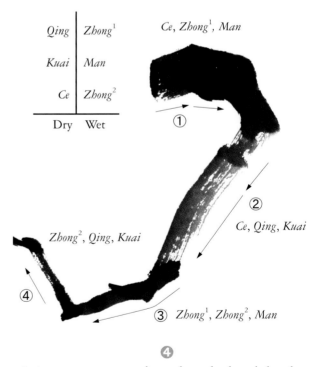

Ce, Zhong1, Man

①

Ce, Qing, Kuai

②

Zhong2, Qing, Kuai

④

③ Zhong1, Zhong2, Man

❹

It is common sense that when the brush has been soaked in water, whatever liquid in the brush will flow down faster when the brush is held upright and will run more slowly when the brush is held at a slant. In a centered-tip stroke the upright brush is pressed down and pulled at a more leisurely pace, the ink will consequently have ample time to be

absorbed by the paper and what results is a wet stroke. If the brush is held at an angle and is not pressed as hard against the paper and is pulled at a faster pace, there is less time for the paper to take in the ink; what results then is a "flying white" (broken ink wash effect), namely a dry stroke. It is therefore essential to learn how to properly manipulate the brush and ink.

IV. Different kinds of brush strokes and ink tones in the painting

The tree trunk sample offers an analysis of the different kinds of brush strokes and ink tones employed in the painting (Fig. 4) . This is a difficult example and it takes long practice to master enough skill to successfully execute it, because it requires the use of a combination of strokes such as the side-brush, flying white, the dry-brush, the centered-tip stroke and the wet-brush stroke etc. Always pay attention to how you enter, execute and exit a stroke and remember the importance of variation in stroke speed, pressure, ink tone and wetness as well as balance in the use of strokes to compose a painting: stroke left before stroking right, stroke right before stroking left, stroke down before stroking up (Fig. 5) or stroke up before stroking down (Fig. 6).

Another technique used in Chinese painting is the *po mo* method (breaking the preceding application of ink), which consists of applying dark (light), wet ink over a preceding application of light (dark) ink before it dries. This method will impart a sense of lively variation and wetness to the painting. You can break light ink with dark ink or vice versa.

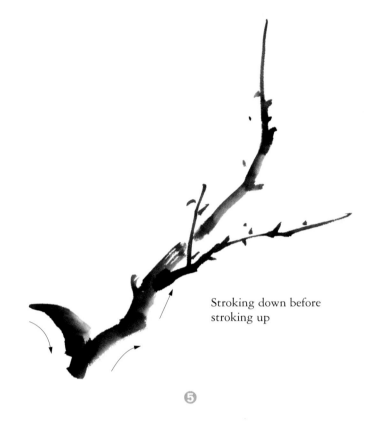

Stroking down before stroking up

❺

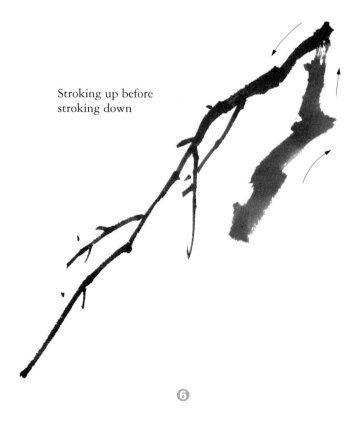

Stroking up before stroking down

❻